ESCAPE

FROM THE

GALLERY

Published in 2022 by Welbeck
An imprint of Welbeck Non-Fiction Limited,
part of Welbeck Publishing Group,
Based in London and Sydney.
www.welbeckpublishing.com

Text © 2022 James Hamer-Morton
Design © 2022 Welbeck Non-Fiction Limited
part of Welbeck Publishing Group

A CIP catalogue record for this book is available from the British Library

ISBN 978-1-78739-601-2

Printed in Dubai

10 9 8 7 6 5 4 3 2 1

Author: James Hamer-Morton
Design: Rockjaw Creative
Design Manager: Katie Baxendale
Editorial Manager: Chris Mitchell
Production: Marion Storz

ESCAPE
FROM THE
GALLERY

AN ESCAPE-ROOM PUZZLE ADVENTURE

JAMES HAMER-MORTON

WELBECK

CONTENTS

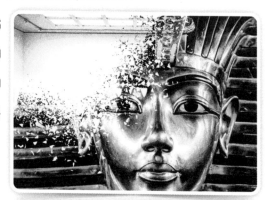

INTRODUCTION

This book is, most likely, different to any other puzzle book you've encountered... unless you've read one of the two previous Escape Room Puzzles books.

This is the third book in the Escape Room Puzzles series, and it is a return to the Wexell Universe that all of Deadlocked Escape Rooms' real-life and digital escape games are based in. In fact, this is a direct sequel to the very first *Escape Room Puzzles* (first published in 2018), and once again you will inhabit the shoes of Adam Parkinson as he unravels the mysteries surrounding the activities of The Wexell Corporation — the global behemoth that is now his employer.

While this is a brand-new story that is able to be enjoyed on its own, there is a short summary of the plot of the previous book at the end of the Introduction for those who want it. If you've not read *Escape Room Puzzles* and want to play it after completing this book, reading the plot might give away its twists and turns, but you will still get much enjoyment from its puzzles. And in one of the chapters there is also an Easter egg for those that have read *Sherlock Holmes Escape Room Puzzles*, as well as other little hints for those who have played more of Deadlocked's games.

Most puzzle books are orderly affairs: regular structuring, clearly defined problems, compact — if difficult — challenges. In other words, they are safe. This is a very different beast. To get anywhere with *Escape from the Gallery*, you need to approach the book one section at a time.

Some chapters have more than one section, and each one is a puzzle made up of interlocking pieces. Some sections hinge on knowledge you acquired earlier on, while most are entirely self-contained. To help Adam Parkinson through the trials inside this book, you'll often need to think outside the box.

The way to approach a section is to read it through, letting Adam show you the things he considers to be of importance. You'll know when you come to the end of the section, because he'll always make it clear that he needs to come up with an answer before he can proceed. Do not read on — the answer is likely to be revealed on the next page!

I KNEW I COULD PROCEED.

Once you've read over the section, go back and look at it again. On this second pass, you'll know what it is you need to end up with – whether it's a word, or a number of so many digits like a date or code, or something that can be translated from numbers to letters using an alphanumeric translation (A = 1, B = 2, and so on).

The puzzles you have to solve in each section will stand out, but exactly how to combine them, or what order to start in, may be less obvious. The text of the book will always guide you, but Adam's hand may be quite subtle in places. It may be as clear as seeing that one puzzle gives you a set of numbers as an answer, and another needs a set of numbers to use as a start point. Generally, everything you solve will lead onto something else that you can use, but there may be points where all factors of a section may provide you with information towards your final goal, solvable only through logical thinking.

So, each section is at the same time a set of puzzles, a collection of hints, and a carefully interlocking jigsaw.

As for hints, each chapter gives you three tiers – available at the end of the book – difficult, medium, and easy. The difficult hints are there to give you a bit of inspiration on how to approach each separate puzzle. Maybe just knowing what to solve next will give you all you need, as the hints are provided in the order that you will need them, and there is a hint provided about the puzzle sequence as well. The medium hints should help if you're stuck, and the easy hints are there for when you're baffled. They will signpost the way forward, although no puzzle in this book is truly easy, even with the hints.

Take your time. Don't expect to sail through the book. Take breaks. Come back later. Give it the time to properly understand each part and you'll have far more satisfaction.

One final note. Some puzzles require physical manipulation to solve. When you see scissors and dotted lines, you're probably going to want to cut things out. If you don't want to damage the book, these pages can be photocopied, and we have also provided a PDF of the "destructible" pages, accessed from the following QR code for you to print at full quality.

Good luck.

ESCAPE ROOM PUZZLES PLOT SUMMARY

Adam Parkinson comes home to find his home has been broken into and his neighbour, Henry Fielding, had been kidnapped. Tracking him to the offices of The Wexell Corporation, he breaks Henry out of a security office and they follow a lead to a suspicious rural shed owned by Wexell.

There, they uncover a secret underground — and underwater — lair, where they break into an office that itself gives access to a huge server room controlled by EROS, an AI on the verge of sentience. EROS sends them on a journey to a library in Spain, where they discover some ancient ruins hiding Wexell's secret: they have learned the ability to time travel.

Adam himself travels through time to save Henry, who has once more been captured, and is shocked to find Henry months in the future working *with* Wexell. It is only then that things begin to become clear. The Wexell Corporation is not an evil company bent on world domination. In fact, they are an enlightened and benevolent group who use their ability to time travel to help humanity develop and progress throughout history. And Bradley Samwell, Wexell's leader, wants Adam to join them …

ABOUT THE AUTHOR

The Escape Room industry is still very young, and yet I feel like it has been a part of my life forever. At Deadlocked Rooms, we've opened multiple venues, designed a tonne of real-life rooms and become known worldwide for our online games. But still, almost every single project starts the same way: a complete fear about how to live up to the previous project. I started writing this book while feeling abject terror at the idea of not being able to come up with enough great puzzles, while also wanting to listen to feedback received on the previous two.

The intention for these books has been to capture the feel of a real escape room – with a gradual unravelling of a series of puzzles in each chapter – while honouring the format itself to try to write an exciting story around them. This narrative approach is something Deadlocked is very passionate about.

However, it turns out that sitting alone in front of a keyboard is not very conducive to creative thinking; at least, not for me. So, much of this book came from sitting in a pub with my partner and Deadlocked co-owner, Charlie, spitballing some of the most ridiculous ideas until something sticks. What you are holding in your hand couldn't have happened without her. Thank you for always getting excited over every new idea. You bring the magic to everything.

Judi, my mother, is always front and centre when it comes to supporting me, and I can never thank her enough for everything she does for me. No harm in trying, though. Thank you!

Finally, there is so much more talent that went into this book. It would be nothing without Katie and Darren's gorgeous design work, and the whole thing wouldn't exist if Chris at Welbeck – and the team there – hadn't continued to believe in what we were making. His enthusiasm and positivity have made this process a pleasure.

I hope you enjoy this challenging, strange, escape-puzzle beast, and that it gives you more enjoyment than frustration. Remember, if you're stuck, feel free to take a break, have another look at the content of the chapter and take a look at some clues at the back of the book, too. Play this your way, and if you've enjoyed this, please feel free to check out the rest of our games (online and not) at **www.deadlockedrooms.com.**

Thanks for playing!

PROLOGUE

e a feat to find a street that was so empty in London, but this was the address
r in my possession. Michelle Samwell, my new boss, was the COO of The
oration, as well as being the wife of the CEO. By her demeanour it appeared
lled the strings on the business side of things. Her husband Bradley Samwell
been responsible for much of the scientific progress that had thrust the
into its current world-leading position. It was at the forefront of technological
nts, and had its fingers in as many pies as it could find, all around the world.
ldn't quite believe it.

e as a journalist had been put on hold after being sent on a mysterious
l quest around the world by my neighbour, Henry Fielding. It was while
g Wexell, which I had assumed had a nefarious plan for world domination,
vered their true secret: time travel.

l unsure about the veracity of what I had already seen. It had only been
e since the time-hopping revelation, and my brain was still whirring with
ethods they could have used to fake it all. It had to be fake ... and yet, how
? Either way, I couldn't refuse the job when it was offered to me, and this was
y — well, night — on the job.

W Henry Fielding

W Adam Parkinson

Where We Excel

Michelle Samwell
The Wexell Corporation

Dear Mr Parkinson,

Congratulations on your new position, and please allow me to offer my own appreciation for signing the paperwork – both the non-disclosure agreement and the contract – so quickly. Your enthusiasm for the project will be as useful as your **cat**-like reflexes. Naturally we can't keep the technology on site in our head office; the power drain alone would invite questions that we are not willing to deal with at this time.

I look forward to meeting you in person, finally, at 8pm next Monday at an address I will send to you by text message on the day. Now is the last time that you can back out, for once you are caught in our **spider**-web unfortunately there is no escaping. Do not fear, however, for both the Wexell Corporation and my own temperament are more akin to a teddy-**bear**, I assure you.

Once you are at the address, find the metal door at the centre of the mural. But don't *count* your **chickens** just yet – you will need to do some thinking before you are able to enter.

Yours Sincerely,

Michelle Samwell

M. Samwell

Chief Operating Officer

The Wexell Corporation
e-mail: info@wexell.co.uk

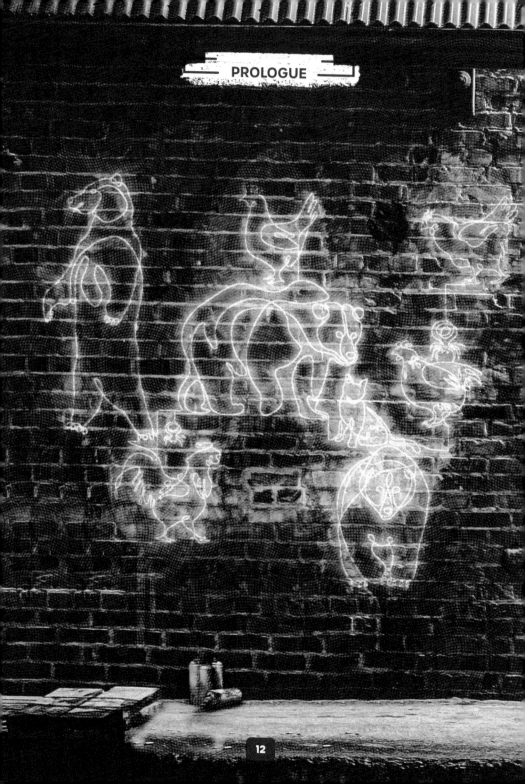

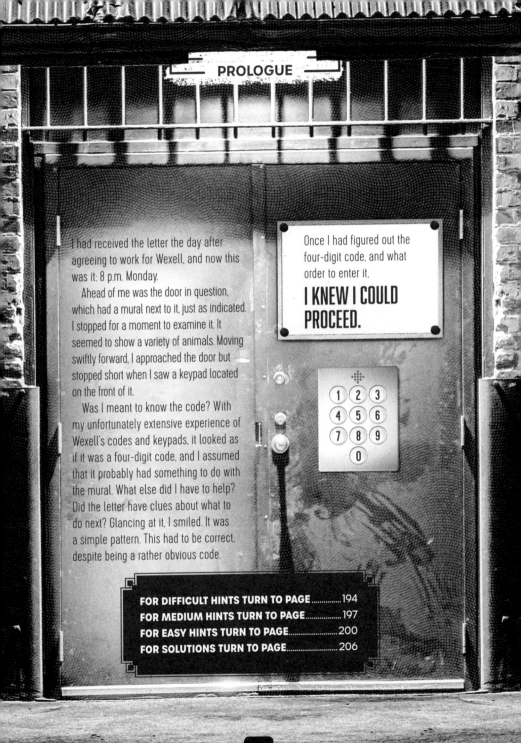

I had received the letter the day after agreeing to work for Wexell, and now this was it: 8 p.m. Monday.

Ahead of me was the door in question, which had a mural next to it, just as indicated. I stopped for a moment to examine it. It seemed to show a variety of animals. Moving swiftly forward, I approached the door but stopped short when I saw a keypad located on the front of it.

Was I meant to know the code? With my unfortunately extensive experience of Wexell's codes and keypads, it looked as if it was a four-digit code, and I assumed that it probably had something to do with the mural. What else did I have to help? Did the letter have clues about what to do next? Glancing at it, I smiled. It was a simple pattern. This had to be correct, despite being a rather obvious code.

Once I had figured out the four-digit code, and what order to enter it,

I KNEW I COULD PROCEED.

CHAPTER 1

ANCIENT EGYPT

The door clanked as I opened it just slightly, creating a small gap through which I could see only white. I gently pushed it all the way open and was surprised to see the pristine monotony of a huge room. It's dazzling plainness was clearly intended to minimize distraction from whatever else was in there. Was this an art gallery?

I could see distinct sections in the wide, open area in front of me — six sections, I thought — the polar opposite of the forbidding alleyway I had just walked through. Paintings on the walls and podiums with sealed-glass cases, dwarfed by the size of the room itself, were dotted around wherever I turned.

Just as I was getting my bearings, Michelle Samwell, my immediate supervisor, strode in, wearing an impeccable suit.

"Mr Parkinson."

"Ms Samwell," I said, awkwardly bowing. Was that too formal?

"Please, call me Michelle," she smiled. It clearly was. *"Do you like what you see?"*

"I'm not entirely sure what it is that I see."

"Perhaps a quick tour, then?" she suggested, backing away and beckoning me to follow. *"You are standing in what we at The Wexell Corporation call 'The Secret Gallery'. Artefacts from around the world, some legitimately borrowed, some accurately copied, are all split into six eras and located in their own sections."*

Looking around, I was in awe. A private collection of these items must be worth a fortune, although the resources of Wexell made this a bit less surprising, it was still a lot.

"We have much to discuss about how and why we acquired these items, but that will come later. For now, consider this ... museum of wonder ... to be your playground." Michelle spoke in a precise and thoughtful manner. Her pauses indicated that her every word was considered.

"I hear you have already experienced our proprietary technology?"

"The technology?" I stuttered, still unsure if what I *thought* I had experienced a few weeks ago was indeed accurate.

"The time machine," Michelle clarified.

So, that was that then. My experience of Wexell was limited, but I could not deny what I had seen with my own eyes. They had somehow invented a method of travelling through space and time, which was achieved by visualizing something that you had a connection with. I still thought it was bonkers, but Michelle seemed to believe in it.

"I trust you understand now why you are in this place?" Michelle asked.

My mind whirred with possibilities. This gallery was full of remnants of different times.

"The art! Art can be a connection to a specific time and place without you having to have experienced it yourself in person."

"Precisely," Michelle said. *"It is a physical connection to someone or something else. And what survives from millennia ago?"*

"The art ... of course. It's how we can know a time or place as the artist experienced it. So, I'm here to ... what? Visit all of these places?"

"That you are."

"Why these places, in particular?"

"There will be time for that later. First, let's see if you can even get it working."

"It?"

Michelle held out a small device – an earpiece, I correctly assumed – nestled in a technophile's dream: a shiny white box with a soft, red velvet interior.

"Take this. It will create a field around you that will act in the same way as our other time devices. Subtle enough that you will not need to explain its presence, yet powerful enough to make the return trip. I will not be able to contact you while you are away, so you are very much on your own."

"Why me? If you know more about this whole thing, then why aren't you going?"

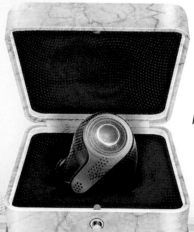

Michelle smiled as I reached to pluck the earpiece from its velvet holder. *"History has ... not always been kind to people like me."*

"I see. So how does this work, then?"

*"We will enter one section of the gallery and explore its artwork. You must find connections between the items there, which will give you something to focus on – a word perhaps, or an image. I like to call it a **'token'**."*

"A token? And that will take me to where this art originated?"

"Precisely."

"And what do I do when I'm there?" I asked.

"I am afraid I can't tell you that."

"Because ..."

"Because we don't know," Michelle admitted. *"You are the first person to attempt anything quite like this. And there are connections between all of these eras that are still unclear. All we do know is that to get back, you will need another connection. Another token."*

I took a deep breath. I realized that if this token — whatever it might be — was the only way of returning, then I would be stuck there should I fail. I looked down at the earpiece and gently fit it into my right ear.

"There is something else," Michelle tentatively offered, ominously stepping closer. *"Your earpiece is, of course, battery-powered and uses the latest advanced technology. But it will be constantly switched on and draining power as it 'listens' for your token. If you do not find the token within approximately 60 minutes in each location, you will be unable to return."*
"Ever?"

Michelle nodded solemnly. A hesitation seemed to rush over her, as though she wondered if she had said too much. I wondered if she had said too little. What was she holding back?

"Well, where am I going first?" I asked.

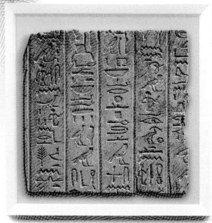

IVTUT

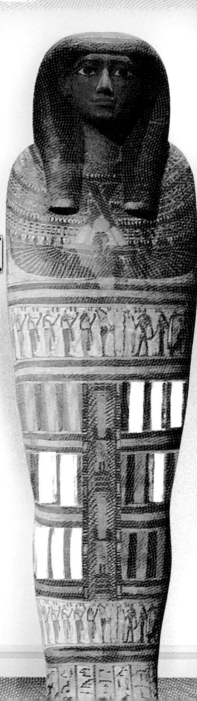

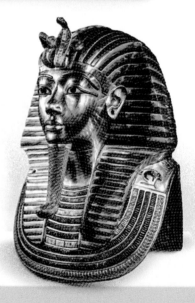

Michelle smiled and ushered me over to the corner of the gallery closest to the door. *"How's your ancient Egyptian?"* she joked. At least, I hoped she was joking.

The central focus was a large sarcophagus at the centre of the exhibit with a plaque on the wall behind it bearing the name "Ivtut", which presumably was the name of the mummy inside. While it was both imposing and magnificent, something about the bottom half particularly intrigued me. Certain sections appeared to be painted white by the ancient Egyptians thousands of years ago, but why would they take the time to create such a beautiful object, only to paint over it?

After taking in the sarcophagus I looked at the walls behind it. There were a number of panels containing hieroglyphs – magnificent, but unreadable to me, of course. It would take someone with the knowledge of the Rosetta Stone to understand them, and that was something I simply did not have available to me. Still, the carvings were truly sensational to examine, and I longed to be able to read them.

Something unusual did stand out though: a map of Egypt, filled with iconography very unlike what a normal map of the time would surely have. In some ways it seemed original, and was painted on what looked to my uneducated eye to be papyrus, but the design was not like anything else in the collection. I wondered whether it could possibly be genuine.

"Is it genuine?" Michelle said, following my gaze and seeming to read my mind. *"As far as we can tell, but..."* she shrugged. I nodded – they were as nonplussed as I was.

I moved my attention to the next item, also hanging from the wall. It was what looked like a scarab beetle amulet, revered as sacred to the ancient Egyptians. On its back was more paint, both black and white, separating the beetle into six segments with what looked like arrows pointing between four of them. Now I was certain; the arrows were clearly not of Egyptian origin, and must have been put there for me.

The last item in this gallery section was another revered animal of the time – a black stone cat. And, of course, it had more symbols on its side with a large X in the middle. What did it all mean?

Michelle glanced proudly at the contents of the area and leaned over towards me. *"Quite something, isn't it?"*
"You don't say!"
"So we need you to get a fix on a specific time and place. Once you solve the puzzle of these artworks, you'll have a year, which we assume will be BCE, and a place name. When you have those, repeat them over and over in your head."

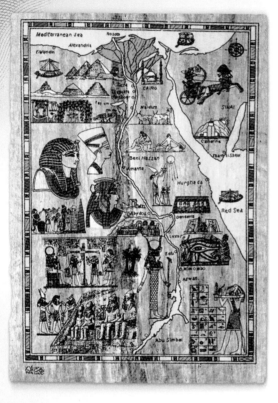

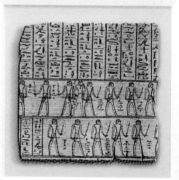

That was what I needed from these items, then: a name and a year. Once I figured those out,

I KNEW I COULD PROCEED.

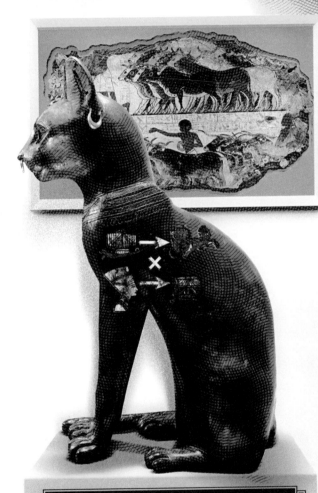

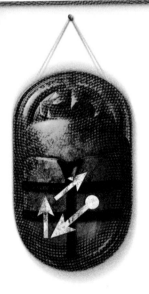

"1323 BCE, Cairo," I muttered.

"You have the place … the date? 1323. That was the year of King Tutankhamun's death!" Michelle ventured excitedly, and pushed in a button that had previously been hidden flush on the side of the white box.

A shot of pain sparked out from the earpiece and enveloped my whole body.

"What was that?" I cried out, my ears ringing from an intolerable sound that apparently only I could hear.

"The earpiece. I turned it on."

"You didn't tell me it would hurt this much."

"Oh, don't be a baby. I'll see you in a bit."

"Is that it?" I shrieked, clenching my eyes shut to avert the pain. *"All the help I'm going to get?"*

"For now. Remember, you have an hour, and don't alter the past otherwise …"

Her voice trailed off into pleasing silence. Then worrying silence. Otherwise what?! I opened my eyes, fearing that I had been deafened by the device. My fears were wrong, but not entirely unjustified. I was no longer in the gallery. I was in a dusty stone room, a red bedraggled material covering the only window, which was wafting sand-filled air through it. I was in ancient Egypt! Cairo, 1323 BCE, I assumed. And now someone was shouting at me.

"PERAMUT NESUT!" is the closest approximation to the sounds I heard, and frankly it was not a good approximation. This was a language with rolling Rs and a rhythmic structure that I had never before experienced. I was no linguist, so any attempt at translating what was being uttered would have to come from inference.

I looked up and a man in golden patterned robes was gesturing towards me, his expression half afraid and half angry. This was all a huge mistake. What was I doing visiting a place and time that was completely alien to me? How was I meant to figure out why I was here, and why were more people entering the room so suddenly?

More talking, and more lack of understanding on my part, led to a feeling of complete inadequacy — and a fair amount of nervousness. I looked around me briefly, and in front of me spotted the very black cat statue that I had seen in the museum. It had been my link here, but what would get me back? And what was I going to do to get out of this situation?

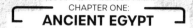

Two short men holding spears approached and swiftly grabbed me by my arms, forcing me out of the room and into a bright and beautifully adorned courtyard. I was temporarily blinded by the sun and felt suffocated by the sweltering heat, but as my eyes adjusted I could see far out on the horizon a sight I had only seen in postcard pictures before: the pyramids of Giza.

My sightseeing was unfortunately short-lived; I was swiftly and roughly bundled into another building, which had a remarkably low ceiling. One of the guards pushed me through the small doorway and smashed my forehead against the ceiling in the process. On top of my other troubles, my head now ached, and I could feel blood dripping into my eyes.

"Beats dealing with the airlines, I guess," I mumbled, to be met with uncomprehending glares from the guard.

English didn't even exist now — England didn't exist now! — so there was no hope of being understood. A gate made of thick, bamboo-like wood was slammed shut behind me. This, I supposed, was their temporary solution to the problem that had just appeared before them: incarcerate me. I turned around and came face to face with something that stunned me even more than the Egyptian postcard vista from earlier, and the crack to the head. It was some writing on the wall — in English!

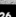

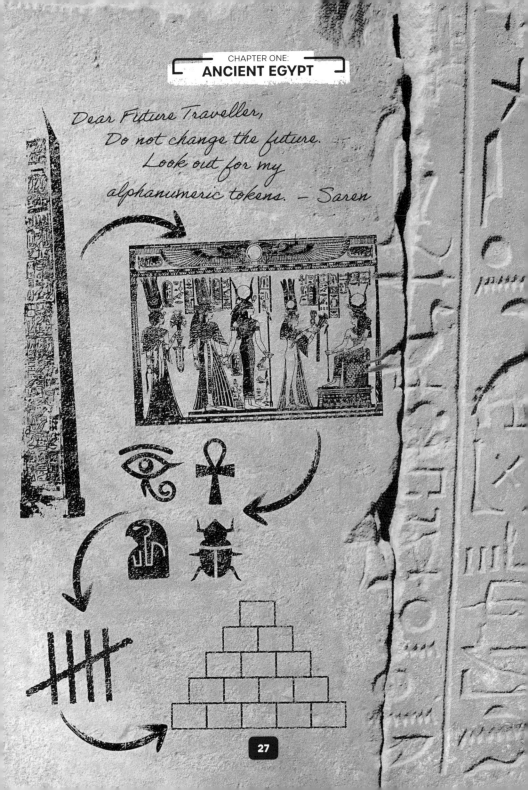

Dear Future Traveller,
 Do not change the future.
 Look out for my
alphanumeric tokens. — Saren

From just those three short lines, I already had a lot to think about. Before I could even begin to turn them over in my mind, a woman in a pale dress entered carrying a wide dish of water and a flannel. She spoke in a language I could not understand, presumably ancient Egyptian. Given my ignorance of Arabic, modern Egypt's main language, I stood no chance. I shrugged my shoulders and shook my head, hoping that she would understand that I couldn't understand. She fell silent, looked at me appraisingly, and dipped the flannel into the water.

While the gate was open, the thought crossed my mind to try to make a run for it. But, no ... where would I go? My head was really pounding now, and the woman moved the flannel towards my head. Instinctively, I flinched away, but I could see her kind smile and so I let her continue. As she tended to my cut I wanted to thank her but didn't know how, so I just nodded and smiled to show my appreciation.

Once she had finished, I looked back at the wall and noticed some hieroglyphs next to the English. They were placed in a large block, and once again I couldn't even begin to start attempting to understand them. I figured it probably wasn't just a translation of the English, though, because what would be the point?

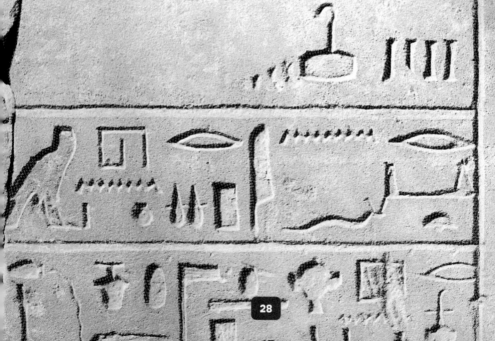

The message from this "Saren" ... Was it intended for me? It was addressed to me, surely? There couldn't exactly be many future travellers, could there?

"Look out for my alphanumeric tokens?" I muttered. *"I do need a token of some kind."*

The woman looked at me with eyes wide and mouth open. *"You speak English?"* she stammered.

"YOU speak English?" I replied, in shock.

"I speak what Saren could teach me," she said.

Saren again. I suddenly understood the situation. Someone had been here before, someone from the future. This Saren had come across this woman and taught her English. His meddling in the past would surely have repercussions, so why was he telling me not to change anything?

"I am Nephthys," she began, *"and I suspect you are from another time."*

I nodded, surprised at her quick assessment. I had imagined that if I ever had to interact with someone in the past, I would have trouble convincing them I was from the future. But Nephthys had come to me with seemingly more knowledge about my predicament than I myself possessed.

"Can you read English, too?"

"No. It was quicker to teach me words by speaking."

"Do you know why I am here?"

"Saren told me you would come. This is why I did not remove the words on the wall."

"He wrote about alphanumeric tokens. Do you know what they are?"

"No."

"But he taught you English because he knew you would meet me?"

"Saren said that you would help us. That maybe you are a doctor?" Nephthys asked excitedly.

"No. I'm sorry, I'm not."

"Then why are you here?"

"I don't really know. To find something to help my people."

"So you are a doctor?"

"Not like that."

Nephthys stopped, confused, but then made the decision to act despite her lack of understanding. *"Look around here. If you wait, I will make you able to leave."*

I looked back around the room and saw a window with a view of the Great Pyramid outside. To the left of the window was a simple drawing of a pyramid, made up of separate blocks, eight rows high. There were scratches on some of the blocks, like tally marks counting something.

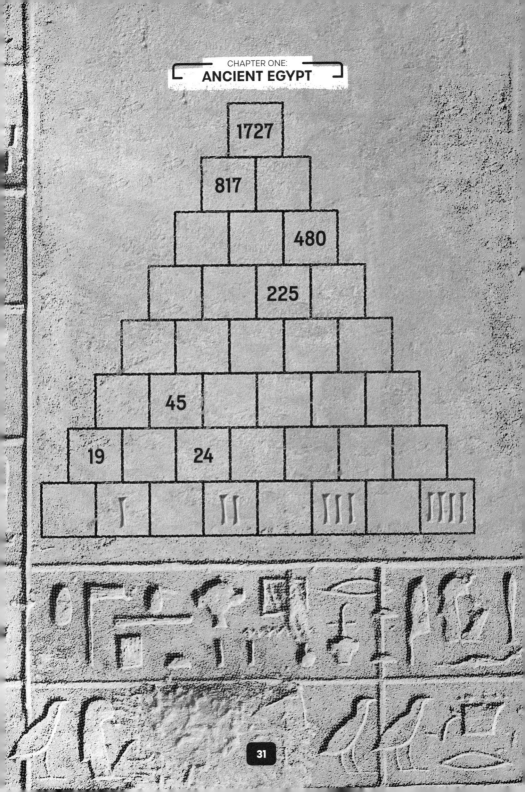

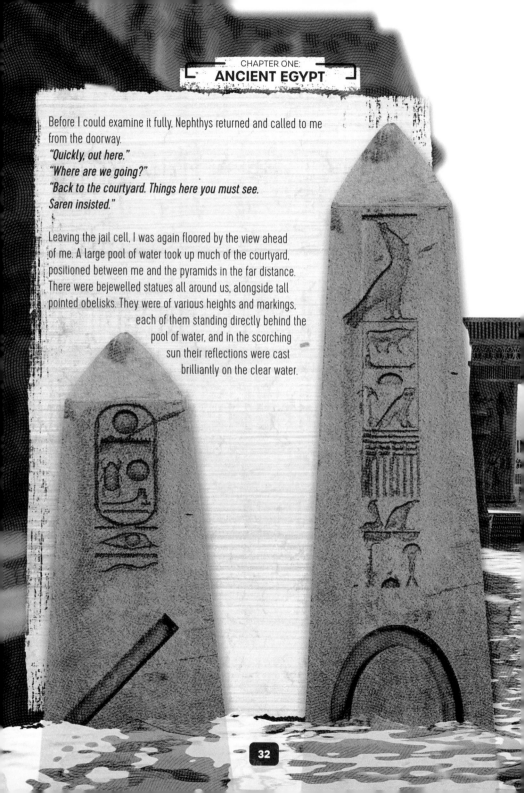

Before I could examine it fully, Nephthys returned and called to me from the doorway.

"*Quickly, out here.*"

"*Where are we going?*"

"*Back to the courtyard. Things here you must see. Saren insisted.*"

Leaving the jail cell, I was again floored by the view ahead of me. A large pool of water took up much of the courtyard, positioned between me and the pyramids in the far distance. There were bejewelled statues all around us, alongside tall pointed obelisks. They were of various heights and markings, each of them standing directly behind the pool of water, and in the scorching sun their reflections were cast brilliantly on the clear water.

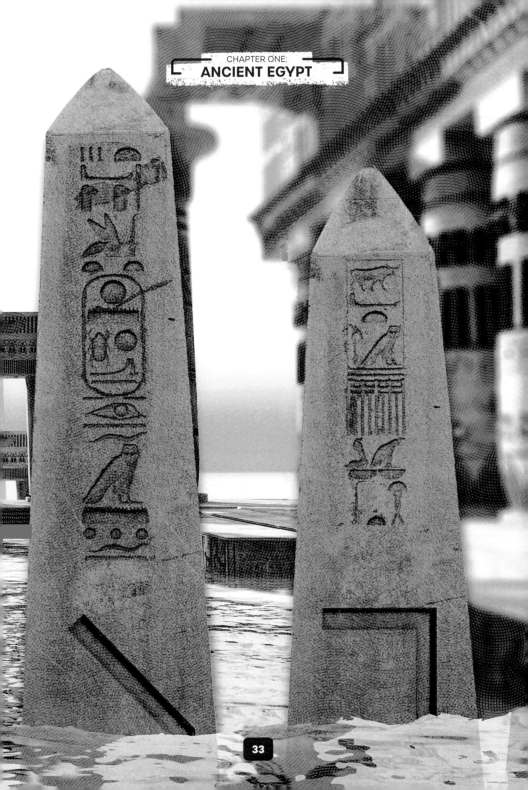

Opulence and luxury surrounded us at every turn, and it suddenly clicked why that must be.

"We are somewhere wealthy, aren't we?"
"The most wealthy. You have been captured by the guards of the Boy King, Tutankhamun."
My knowledge of the era was sparse, but King Tut was obviously a pretty big deal.

"What you call this year? Saren said to me that you count your years backwards."
"Well, only before ... I guess right now we do, yes."
"Are you here to save the king? He has fallen to sickness." Nephthys' eyes were filled with concern.

Swatting a mosquito that landed on my arm, and noticing the incessant buzzing all around us coming from the pool, the thought occurred to me that it could be something like malaria. If so, I could not help. Although, to be honest, if it was pretty much anything I wouldn't be able to help.

"He has not been well for some time, and fell worse recently," Nephthys continued. *"The sickness has been like plague. More falling ill every day. It has already taken most in the area."*

The romanticism of this ancient society was suddenly wearing thin. This culture, despite being very advanced for the age, was still in its technological nascence and vulnerable to disease in a way that I had not taken the time to appreciate before.

I looked around, marvelling at the achievements that they had made despite these limitations. A huge tapestry flapped between two pillars behind me; it was adorned with hieroglyphs that I figured must indicate something about the surrounding area, especially since the markings depicted the obelisks too. An arrow on the left side of the tapestry pointing up made me think that it was telling me something about how to read the obelisks, but to what end?

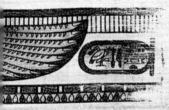

How many minutes did I have left to sort all of this out? I knew the clock was ticking and I needed to focus. I had to use all of the information here to deduce what Saren had been trying to tell me. What had he called it? An alphanumeric token. The token I needed to get home.

Once I had found a hidden word in that format somewhere,

I KNEW I COULD PROCEED.

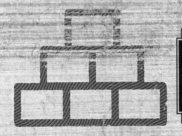

Nephthys? That was the name of my new friend. Why was it hidden in this pyramid sketch? I looked closer. Just to the side of the drawing, almost imperceptible to my eye, was a tiny imprint of eight hieroglyphs running along the side of the window. I beckoned Nephthys over; this must be meant for her to see, if it had her name on it.

"What have you found?" she asked.
"Take a look."

They just looked like shapes and symbols to me, with some legs and a bird thrown in for good measure, but it seemed to shock Nephthys, who gasped.

"It is a warning," she said.
"What does it mean?"
"More like a word. It means –" she paused as she tried to find the word *"… calamity."*

Calamity. The word flashed through my mind like a pulse of energy – energy that stung the side of my head. Of course, the earpiece! I had felt the same sensation as when I focused on Cairo, 1323 BCE, and I knew that "calamity" was the token that would take me back.

"Nephthys, thank you for your help."
"I did nothing."
"I am glad to have met you."

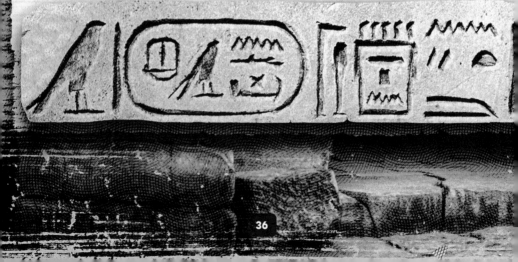

"You are going?" she ventured, looking at me with concern.

"I'm afraid so. And I need you to promise me one thing."

"Promise?"

"Yes. It means you tell me you will do something, and you do it no matter what."

"Okay. I promise you one thing."

"I haven't told you yet."

"Saren convinced me to trust anyone like him."

"Well then, I need you to promise to never speak about me or Saren again."

"Why?"

"I just need you to promise, okay?"

"Okay. I promise. Have you done what you needed to do here?"

"I think so, but I don't understand it yet."

"Neither do I. But I wish you good luck."

I smiled at Nephthys. I didn't know if it was as important to her as it was to me and the world's future timeline, but I hoped she could keep her promise. I needed to avoid changing the future. That was Saren's message to me, and I realized that it probably wasn't just for my benefit.

Calamity? What could that mean?

The thought of the word sent shock waves through me again and again. Calamity! The pain shot through the back of my eyes, forcing me to close them, and the air around me suddenly became colder.

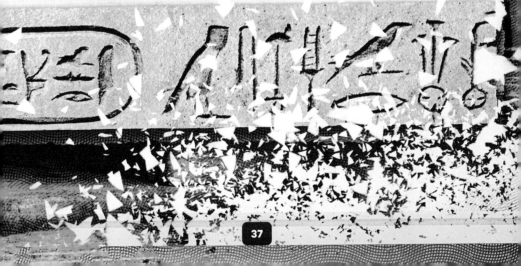

"... the universe will find some way of readjusting." Michelle's voice was immediately calming, but at the same time alarming. I opened my eyes. It seemed that my brief adventure, that had left a lasting impression on me, had passed in no time at all to her.

"Are you okay?" she asked, in a more caring fashion than I had heard from her before.
"I'm back," I blurted.
"I wasn't aware you had even left. How was it?"
"I was away for nearly an hour. I really went back in time! It was ... eye-opening."
"What did you find? What was there?"
"I think I was there for a word. The word 'calamity'." I shivered as I said it. The more I thought about it, the more ominous it sounded. *"Why would Saren want me to think of calamity?"*
"Who is Saren?"

I realized that I had a lot to explain. I quickly ran through my visit to the world of King Tutankhamun, Nephthys and her surprisingly good English and, of course, the word — the token that had brought me back. Michelle stood in silence for a few moments, then sprung into action.

"Follow me, and please pass me your earpiece," Michelle said.

She took a pair of plastic gloves from her suit pocket and put them on, being careful to stay well away from me as she plucked the earpiece from my now outstretched hand. Walking diagonally across the room, I glimpsed some of the other pieces in the gallery that may well become my future adventures, but my mind was in too much of a whirl to take any of it in. Michelle brought a walkie-talkie to her mouth and began speaking.

*"Dr Soutar, it was immediate. I hope you're ready. We may have a problem with Mr Parkinson.
Be ready. Code 5, of course."*

That sounded even more ominous than calamity. Michelle's hands returned the walkie-talkie to her belt and I could see her practically kick herself as she swiftly pulled out a face mask from her inside pocket and held it over her face, too rushed to even put it on properly. I had to break into a little jog to keep up with her. Her obvious concern for her own safety — from me! — began to alarm me.

"Is everything okay?" I asked.
"Absolutely fine. Just precautions, and I have to get this earpiece recharged," she replied, without facing me or batting an eyelid.

We reached a doorway nestled perfectly in the corner of the vast room and she flung it open, not pausing to hold it for me. As I followed, I could see a man in a yellow hazmat suit looming ahead. I slowed down for a moment in trepidation, but was swiftly beckoned on by the man.

"This is Dr Soutar, Adam. He will just check you over between trips. Standard procedure."
"I thought I was the first to do this."
"Yes, well … it's the standard procedure now."

Michelle darted off to a room to the side. As I passed the doorway, I could see her scrubbing the earpiece with an antiseptic wipe, her eyes not moving from the task. The masked face of Dr Soutar offered no comfort either, and his first words to me weren't exactly music to my ears.

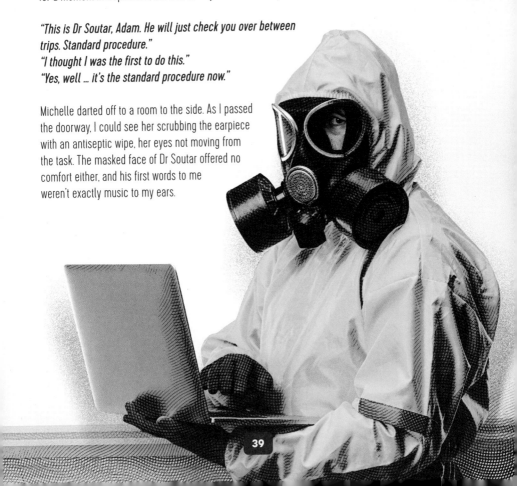

"Come in here and take your clothes off. We'll need
samples of everything."
"Aren't you going to buy —"
"Yes, buy you dinner first. Good one. Very
original," the doctor interrupted, tersely.

He led me into a sterile white room filled with
equipment, like a section of a hospital had been
ripped out and planted somewhere completely
out of context. Despite a bed, and what looked like a
long black leather table, it was more like a laboratory
than a ward. Dr Soutar walked straight over to a tray of
syringes and began taking one out of its airtight packaging.

"Been working here long?" I asked, searching for something
beyond the usual weather small talk to lead with.
"I have been brought in just for this project, actually," he said.
"And what is this project?"
"I think you probably know more than me, Adam."

I was weirdly pleased that the doctor had skipped formalities and gone straight
to addressing me by my first name. It was a speck of comfort for me in these
tense moments. Perhaps it was intended to put me at ease. Suddenly, one of
the machines let out a high-pitched bleep.

"Samples, please. The machines are all warmed up," he said as he
raised a syringe in the air.

I couldn't help but be impressed by the preparation and timing that
had gone into this operation. I had no doubt he was at the top of
his field, and frankly, with Wexell's budget, this did not surprise me.
It reminded me of the physical I was required to have a few days
before starting work for the company, when I had presented myself
to have a blood sample taken. A quick and near painless prick
in my arm, but still I had needed to look away, which
was an odd admission from someone willing to
time-travel, I had to admit. It was not the blood itself

that made me uncomfortable, but more the thought of it being deliberately removed that I had always had issues with.

"So, what do you think calamity means?" asked the doctor, quite abruptly. I turned to look at him, even though I could barely see his face through his hazmat suit. *"I overheard you when you arrived,"* he explained.

"Why do you ask?"

"It's a classic distraction technique so that you don't think about what I'm doing to your arm." And with that, the needle was already out. The distraction had worked. *"Now, I still need to examine you further, I'm afraid, so the rest of your clothes need to come off. Drink that, and lie down on that bed on your front,"* he said, gesturing over to a cup of what looked like orange juice by the leather table, which was partially hidden by a curtain.

I obliged. The bed was unnervingly cold, complemented by the drink itself, which had clearly been taken out of the fridge just before I had arrived. It didn't help that I was putting my bare chest directly on the freezing leather, of course. The doctor immediately busied himself with inspecting my arms and legs, stretching my skin as if checking it for injuries.

"I was nearly bitten by a mosquito on my right arm, if that helps?" I volunteered.

"It does actually. Thank you," the doctor replied, a bit more warmly.

"So, what exactly are you looking for?"

The doctor paused.

"Any risk of contagion," came a voice from the doorway. Michelle had returned. Despite being hidden behind the curtain, I felt a little exposed in her presence.

The doctor explained, *"Travelling to different times and places contains an inherent risk. Not just of you contracting some ancient long-extinguished disease, but bringing them between time periods. Imagine bringing something new to a time or place unequipped to deal with it."*

"Am I in danger?" I asked, shaking now, perhaps from the cold, but more likely from the new information that I couldn't help but feel should have been explained beforehand.

"Not especially," Dr Soutar said. *"You're far more likely to die from something while you're in another time period than bring something back here that we can't deal with, but it's worth being careful."*

"Of course ... I understand." This was the least reassuring "reassurance" I had ever heard.

"Calamity," Michelle blurted out. *"What do you think it means?"*

I paused, wondering if I should be talking so freely in front of the doctor. Michelle sensed my discomfort.

"Don't worry about Dr Soutar. He has the highest clearance." She paused. *"I am going to have to leave for a moment to update our boss. You'll be okay here with him, won't you?"*

"Of course," I said.

"I was talking to the doctor."

"See you soon, Michelle," Dr Soutar warmly replied.

And with that, I could hear her footsteps echoing down the corridor. My inspection had concluded, and the doctor handed me a small cup and gestured at a small toilet in the corner.

"Quickly, please," he said, as I went over and started attempting to fill up the cup.

"Are we in a rush?"

"In a sense."

I managed to urinate, despite a little shyness, sealed the top of the container and passed it back.

"Why?" I asked, the blood rushing to my head, perhaps from standing up too quickly.

"Please, you need to rest while I run these tests. Put on that gown." He gestured to the bed, where I saw a comfortable-looking blue gown that in one sense made me feel relieved that I got to put something back on, but in another sense concerned me that I might be being prepared for some sort of surgery.

"I don't feel well," I said, then immediately wondered if I should have been so quick to admit my dizziness.

"The gown, please."

I obliged, and felt weak. *"What's happening?"*

"That would be the sedative in the orange juice. Nothing to worry about. You just need your rest."

"I ... but I ..." I managed to choke out.

The doctor caught me as I began to fall over, gently placing me into the bed. I shut my eyes and stopped fighting what would be the best sleep I had ever had.

VICTORIAN ENGLAND

I awoke with a start. Partly because my body had been fighting whatever drugs had been given to me, and partly because I didn't appreciate being uninformed about being drugged. No one was around, but I saw a chart on the bottom of my bed and swung around to try to grab it. I was still a bit woozy, but I could see that it seemed to show a table of potential infections with **"NEGATIVE"** written beside each one.

That was a relief, albeit a brief one; Dr Soutar returned, still fully protected in his plastic suit.

"My apologies for taking you by surprise. Ms Samwell assumed we had more time before you returned, and therefore we were unprepared," he explained.

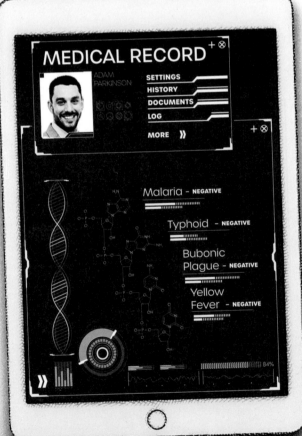

"You were already in your hazmat suit, though."
"Oh, this old thing? It's just something I threw on."
"My chart says I got all negative results. So why are you still wearing it?"

He paused. It was hard to get a read on him under the suit.

"Aren't doctors meant to reassure their patients?"
"Surely the chart is enough for that. Let's just say I want to be ready for the next time. Now if you don't mind, I believe Ms Samwell is waiting for you."
"Can I take a shower?"
"Of course. Just through there."

He indicated a door by the foot of the bed and I took my leave. While I didn't feel like it was completely necessary, the fear of possibly being contaminated made me just want to feel clean.

After my shower, I put on some new clothes I had been given. They were plain, simple and seemed deliberately nondescript. I noticed there were no buttons or zips, and it felt like there were no synthetic materials. That made sense; they were trying to make me not stand out when I visited other time periods. I wished they'd have given me them before my first trip, but I guessed that I would have stood out in ancient Egypt no matter what I was wearing.

The doctor was still in the room that I had slept in, and gestured towards the way out. I strode back into the main gallery, trying to appear more confident than I felt, and saw Michelle standing in a new section — opposite the ancient Egyptian area — perusing papers on her clipboard.

"Welcome back," she said distractedly. I wasn't expecting fanfare, but come on ... I'd just come back from 3,000 years ago! Surely I deserved a little congratulation.
"So, what's next?"
Michelle finally smiled and turned towards me. *"Eager. I'm impressed. Take a look around. Oh, and you'll be needing this."*

Michelle handed over the earpiece, apparently fully recharged and ready for action. I installed it in my ear once more and prepared to investigate the area.

The second gallery installation was busier than the first, with quite a few more objects. I was bemused by the sheer number of clocks, each one showing a different time.

Michelle was following me. *"No matter what we do, we can't seem to get the clocks to start."*

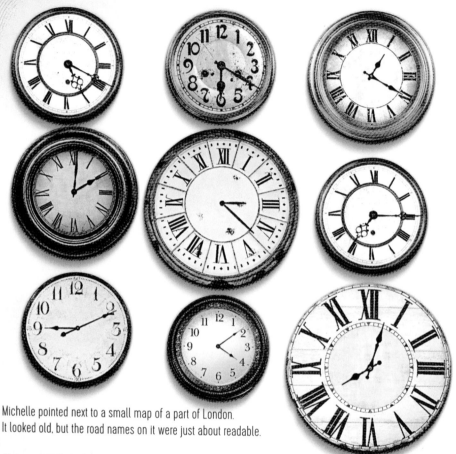

Michelle pointed next to a small map of a part of London.
It looked old, but the road names on it were just about readable.

"I assume that the location is London, then?" I asked.

"We think it might be more specific than that. Perhaps you are looking for a specific place in London located in this map. A street name? Unfortunately, the map itself is not ideal – some of the street names are incomplete. For someone of your talents, it shouldn't cause much trouble."

"That's kind, thank you."

If the word I found at least partially matched a street name, I could be sure I was on the right track.

I next approached a series of artworks. The first was a painting of a man in front of another painting with some kind of ghostly figure emerging from it. What could this mean? Was something meant to leap out at me from the pieces, or was I being too literal?

There were more paintings and artworks arranged tastefully for me to examine.

The final object in the room was a nicely displayed piece of porcelain. The images depicted on it were unusual, and seemed suggestive of something, but what?

When I had determined the street name, and the year I was heading to,

I KNEW I COULD PROCEED.

"1894. Here in London. Tavistock Street?"

A flash – and another sharp pain – sent me into myself and back out to a colder place. It was night, and the soft glow and flicker of oil street lights perforated the darkness. I must be in London in 1894!

"Hey, where'd you come from?" shouted a male voice from behind me.

I spun around, not sure what to say, and ended up saying nothing.

"It's all right," the voice continued. *"You're probably the strangest thing I've ever seen, but still, you could say I've been expecting you."*
"You have?"
"Your friend sent me." My eyes were adjusting to the gloom, and I could now see the man had a tall hat, pale skin and a long dark overcoat.
"Saren?"
"Who?" the man asked.
"My friend. Why, who do you think my friend is?"
"Aiden, of course."
"Of course." I nodded nervously. Playing along was probably the safest course of action in this place. *"Is he here?"*
"No, long gone. But he said you'd be here, now, and that you'd help us."
"Help you? With what? I need to know what ... Aiden ... did."
"Tell you what, squire ... you help us with our little problem, and we'll help you."

I didn't have much of a choice. While thinking over my options, I became aware of the overwhelming stench of the streets and the dinginess of the environment. All the more reason to go along with this man, who at least seemed to be expecting me. Was I in any danger? Jack the Ripper must have been around in the 1890s but my knowledge of history wasn't good enough to be sure whether or not I was slap bang in the middle of all that or not. He was carrying a bulging doctor's bag. Could the bag contain some kind of gruesome body part? In the end, I decided that Saren – or Aiden – had guided

me successfully through Egypt, and I would have to trust them again now.

"Fine. What do you need me to do?" I sighed.

The man led me down the street and around a few corners to a police station. My heart sank; whatever I needed to do here was almost certainly not going to be legal. The man opened his bag and reached in. I tensed, ready to run — an automatic fight or flight response to being in an unknown place at an unknown time, with an unknown person. Not unreasonable, I thought. He took out a cake.

"I need you to deliver this cake to my associates held within this police station," said the man.
"And you can't do this yourself?"
"We can't risk being recognized by the authorities. We need a fresh face."
"I don't even know your name."
"It's Jimmy. But I could have just made that up."
"I'm Adam ... Parkinson. So why should I do as you say?" What was the point of lying?
"Come on, mate. We're all working for The Fellowship."
"The Fellowship?"
"You know ... The Wexell Fellowship."

The name hit me with a jolt. But, of course, The Wexell Corporation had been working in the shadows for centuries. The **"Fellowship"** moniker made sense for this time period. And anyway, I didn't really have a choice.

"All right, I'll do what you ask."

Jimmy passed over a small piece of paper with exactly what to say to the prisoners, and I took the cake in my other hand.

"So, what, is there a file inside this?" I asked.
"A file? It's just a cake," Jimmy insisted, looking confused. *"A cake to help them escape."*
"An es-cake?" I joked nervously.

Jimmy met me with silence. I guess the cake itself had to be important, but that wasn't really my problem. I just had to get in, reach the cells and hand over the cake. What they did with it would be their problem, and a whole other story.

Jimmy broke through my thoughts. *"When you're ready."* I strode into the police station, confidence my sole weapon. An officer stood at a desk in front of me.

"Can I help you?"
"Yes, please. I'm here to see someone. Someone held in the cells."
"I'm not at liberty to just let anyone in off the street."
"It's okay, the Captain said that I could just go in."
"And I'm meant to take your word for that? No chance."
"Well, the Captain's word."
"I'll tell you what — the Captain's due back in 15 minutes or so. If you just wait here, we can ask him ourselves," said the officer, smugly.
"That sounds just great." I beamed at him, hiding my grimace with a smile.

I had to come up with a way of distracting the officer before the Captain returned. I nonchalantly stood to the side, looking over at the noticeboard just behind the reception, and placed the cake on the desk. I had to be able to find some information that I could use to remove the man behind the desk from his post. I couldn't see a name tag anywhere, but on the noticeboard was a document listing the staff members of the police station by name, and their next of kin.

Perhaps if I could figure out who he was, I could use this list to find someone important to him and use that information to get past him.

CHAPTER TWO:
VICTORIAN ENGLAND

Name	Pay grade	Times of work	Date of birth	Next of kin
Allen	3	Mon, Weds, Thurs, Sat - 8am-10pm	3rd July 1861	Joan Allen
Bennett	1	Tues, Weds, Thurs, Fri - 5pm-5am	17th Dec 1865	Hugh Bennett
Clark	4	Mon, Tues, Weds, Thurs, Sat, Sun - 12pm-12am	12th Oct 1851	Tim Clark
Clarke	7	Mon, Tues, Weds, Sat - 4am-2pm	1st Nov 1852	Mary Clarke
Davies	2	Tues, Weds, Thurs - On call 24 hours	22nd Feb 1854	Angela Davies
Hill	5	Mon, Weds, Fri, Sun - 11am-11pm	29th June 1840	Jack Hill
Jackson	3	Mon, Thurs, Fri, Sat, Sun - 4pm-4am	26th Oct 1852	Emily Jackson
Johnson	5	Weds, Thurs, Fri - 6pm-12am	31st Oct 1859	Elizabeth Johnson
Lowe	8	Sat, Sun - 9am-6pm	10th June 1845	Jessica Lowe
Payne	8	Mon, Tues, Weds, Thurs, Fri - 9am-6pm	6th Jan 1839	Gareth Payne
Taylor	4	Tues, Fri, Sat, Sun - 6am-2pm	18th Apr 1856	Isabel Taylor

STAFF TRAINING SCHEDULE

The following staff are in training and therefore must be covered on these days:

Allen, 14th June

Clark, 19th June

Jackson, 21st June

Taylor, 25th June

HOLIDAY BOOKING

These staff are away on holiday for the following days:

Bennett - 1st June-7th June

Clark - 20th June-26th June

Johnson - 12th June-19th June

Lowe - 24th June-30th June

Payne - 24th June-30th June

But first, I needed to deduce who he was. Once I was sure of that,

I KNEW I COULD PROCEED.

WEEKLY MONDAY INSPECTIONS

4th 11th 18th 25th

Receptionists must be pay grade 3 or higher. If a grade 3 is not available, then it must be a grade 4. If no grade 4 is available, then grade 5, etc.

THIS MONTH'S BIRTHDAYS

Happy Birthday

Hill and *Lowe*

Please thank our local greengrocer who has been kind enough to supply us with different fruit on each day for another week.

Monday

Tuesday

Wednesday

Thursday

Friday

Saturday

Sunday

Johnson. It had to be him on the front desk. I looked over to see the next of kin. Elizabeth Johnson. Possibly a wife? I wandered outside, trying to appear casual.

"Jimmy?" I called in a sort of hushed shout.
"You delivered the cake?"
"No, not yet."
"Where is it?"
"I left it inside on the front desk."
"The officer better not have eaten any."
"Damn it! Look, I need your help. Rush in after me and ask if there's an Officer Johnson working. Say that Elizabeth is in the hospital and needs him."

I turned before he could reply, hoping he would appreciate the urgency, and was relieved to see that the cake was still intact. A couple of minutes passed, and I started worrying that Jimmy wasn't coming. Just as I started to head outside again, he entered, dripping with sweat and mopping his forehead with a handkerchief.

"Johnson?"
"Yes?" the officer cautiously acknowledged.
"It's Elizabeth. She's in hospital. She needs you."
"Oh my Lord!" Johnson blurted out, jumping to his feet. *"But I can't leave my post!"*
"I've got this, my friend —" I started, *"and besides, the Captain will be back soon, won't he?"*
"Yes, yes, thank you," the officer said, barely glancing at me as he ran for the exit.
"Where is she?"
"Where do you think?" Jimmy blagged.
"Oh, right ... of course."

Jimmy removed the handkerchief — a clever way of avoiding showing his face — and took a small bow.

"Now for the cake."

"We're past the guard now; why don't you go in?"

"Let's just say that I can't afford to let the people in that cell determine who I am, and they are good at what they do. You're the only person able to stay in the shadows."

"And I have to say it exactly like you wrote it?"

"Exactly like I wrote it."

Jimmy stood guard while I dashed in and delivered the item. Everything went smoothly, even if it all seemed a bit suspicious, but I had done my part. I just had to hope I wasn't helping to break out ca criminals. There had been two men in the cell and one of them had looked suspiciously like Sherlo Holmes — but he was a fictional character ... wasn't he? The cake seemed to mean a great deal to prisoners, and its delivery sparked much hushed discussion and gesticulation before I took my lea let them get on with whatever adventure they were in the middle of. Now it was time for Jimmy to d for me.

"We're trying to get them to work with us at The Wexell Fellowship," Jimmy began, as I returned. *"As you can imagine, they would be incredibly useful additions to our roster."*
"I can, yes," I agreed, as I tried to get away from the station as quickly as possible.

We walked around a corner and Jimmy gestured to a horse-drawn carriage that was waiting for us. I climbed in, simultaneously fascinated by the everyday details of life to which I was privy in my brief time here, but overwhelmingly nervous about how much this ride would eat into my 60-minute time limit. I just had to keep trusting Saren/Aiden, which wasn't a comfortable place to be in.

"Where are we going, Jimmy?" I asked.
"Does it matter?"
I shook my head and smiled to myself, trying to control the punch of adrenaline coursing through my body. Thankfully, the journey did not take long, as I was becoming increasingly aware of my earpiece slowly draining of its power.

"Here we are," Jimmy announced. *"This is where your friend was. He was here to see our expert, and I'm bringing you to them now. Just one thing — try not to be shocked. Our expert is a woman."*

I waited for the punchline, but it never came. Such an odd thing to say, I thought, until I realized why this was a big deal; I was visiting a time when the concept of gender equality was a long way from mainstream acceptance. Whoever this expert was would surely be very formidable.

Jimmy led me up some wooden steps to the side of a building that stretched to the edge of a street. At the top of the steps was a heavy door. Jimmy shoved hard, and it opened on to a shocking sight: a dead body sprawled naked on a table with a woman looming over it, wearing a nurse's outfit. The expert?

"You must be Aiden's friend," the woman guessed.
"I may well be," I replied, not wanting to give too much away. *"And you are?"*
"Call me Flora."

Was that a real name? Suddenly, I was hit by the smell in the room. Expecting something dank and befitting what must be an autopsy room, I was instead greeted with an unexpected aroma of sweet flowers. Floral. Perhaps that was why she went by Flora?

"Fear not ... We are not at risk of miasma here."
"I am sorry, Flora ... I should have introduced him. This is Mr Adam Parkinson."
"A pleasure. Now, I assume you are wondering what we are doing here?"

"An autopsy."

"Correct. How do we learn from things we do not understand? We experiment. This is what we are doing here."

"I'm sorry," I interrupted, *"but you mentioned miasma?"*

"Yes, bad air. Some illnesses seem to be transmitted by the smell," Flora said..

"Okay," I acknowledged with scepticism. *"And what exactly was wrong with the poor chap there?"*

"The pox," Jimmy said.

Flora looked over at Jimmy. *"But we have more patients with the plague at the moment."*

I remembered my decontamination process back at the gallery, and it became more and more uncomfortably relevant. I caught myself unconsciously stepping away from the body.

"So, your friend left some things for you. Would you like to see?"

"Of course," I said eagerly, wanting nothing more than to hurry onwards.

Flora smiled and put down the scalpel I had previously failed to notice in her hand. She picked up a small lamp next to her, walked to the door at the opposite end of the room and opened it. I had to slightly duck through the doorway, but then came face to face with a room crammed full of beds, all filled with sleeping patients.

"The layout was not my decision," she said. *"Aiden was very specific about how things had to be arranged."*

For some reason, Aiden — or Saren, assuming it was indeed the same person — had left a series of clues for me, rather than simple instructions that would have saved much of my time. Why, I still didn't know, but I had to fulfil my objective. I tapped down my pockets in the hope of finding some kind of notepad to scrawl my thoughts on, but was left empty-handed. Jimmy noticed and nearly leapt over, a wooden clipboard in hand. A single sheet of paper was attached.

"Here you are."
"Thank you."

His mood had now entirely changed, apparently just from the presence of Flora. I smiled at him as he passed over a pencil. I quickly sketched the room layout, and upon doing so noticed that the bed wheels seemed to have been locked in place — each bed could only move lengthways, back and forth along one axis from front to back, not side to side. Each bed also had a number written on the legs, and one had "2nd" etched into it as well.

When I asked about this, Jimmy jumped to life, eager to explain something he understood. "Aiden drew those on while rearranging the room," he said.

After another look, I spotted that one of the beds had a star on it, and was pointed directly at the door on the other side of the room, which was currently blocked by another of the beds.

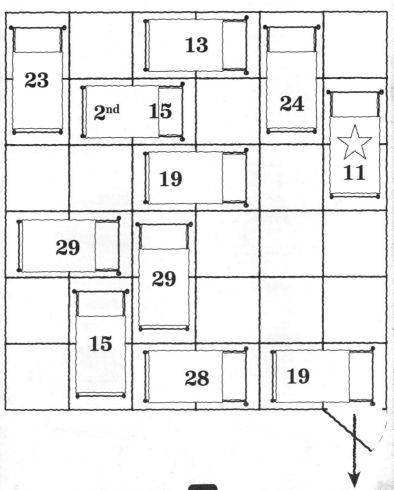

"*What's wrong with all of these people?*" I asked.

"*A variety of things,*" Flora replied, sadly.

"*What symptoms do they have?*"

"*We do not treat the symptoms, we treat the patient. That way we can look for the root of the problem.*" Jimmy practically hopped into the room, excited to hear Flora talk about her work. "*Our 'Lady of the Lamp',*" he proclaimed proudly.

I balked a little at the juxtaposition of the care Flora was giving her patients in one room and the graphic autopsy occurring just next door. She seemed to notice as I looked between the two.

"*We must all act for the greater good. We work — we even suffer — so that we can save lives later. All I can do is try to save the life in front of me.*"

I understood that while her actions and methodology may not stand up to scrutiny in our modern age, her work must have been a stepping stone on the route from an absolute lack of knowledge to modern medicine. Even in my world, there was still plenty that we didn't know.

I took a look at some of the wooden clipboards hanging from the edge of each of the beds. Seeing me do this, Flora spoke: "*Aiden was very helpful with those, but he added some parts that I still do not quite understand.*"

The charts had various pieces of information about each patient, but four of them stood out. They had drawings that seemed similar to a heart rate monitor from my age. Only ... the heart rates were so irregular that they didn't make sense. They must be some clue for me.

"*He had some very strange ways,*" Flora said.

"*Aiden?*"

"*Yes. He insisted that for ... something about confidentiality, he wanted to use code names for each patient.*"

"*So these aren't their real names?*"

"*No. Perhaps bear that in mind.*"

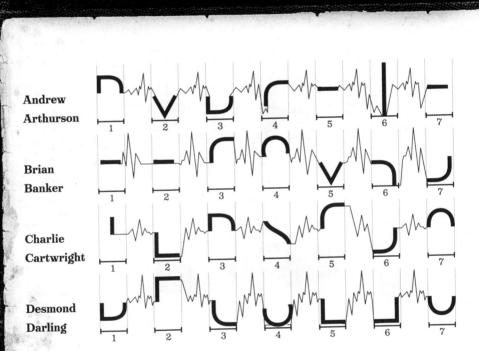

Andrew Arthurson

Brian Banker

Charlie Cartwright

Desmond Darling

Upon closer inspection, what I had thought were the charted heartbeats had numbered sections underneath them. Perhaps there was some encoded information in the heart rate charts that, when combined with the patients' names, would be revealed to me. I thought I had best keep investigating, in case I needed some more information to make sense of the images in front of me.

I took a step back, confused at the lengths to which this Aiden had gone to obfuscate his intentions. Were they intended to just be relevant to me, messages through time that would be unclear to those who held them until I arrived?

Looking around the room, I noticed what looked like a number of large pieces of wood leaning against the wall.

"He left those, too," Flora noted.

"What are they?" I asked.

"I do not know."

I took a look at them. Four of them had small grooves of irregular shapes carved into them, while the fifth had a number of chunks hollowed out of it, as well as an inscription reading "Lady of the Lamp".

"Lady of the Lamp" was something Jimmy had said earlier. I looked down at the lamp that Flora was carrying and gestured towards it.

"May I?"

"Of course."

Holding the lamp up to the piece of wood threw precise but unusual shadows on to the back wall. Twisting the wood around gave four different iterations of shadowy figures.

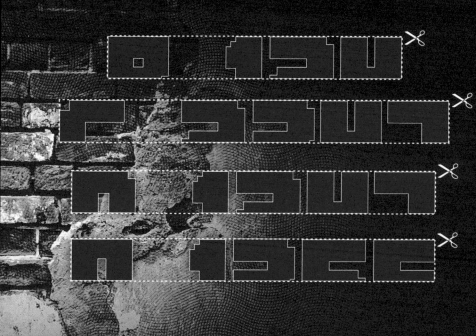

"Malaria – a disease caused by foul air from marshy districts. The name is derived from the Italian *mal aria* meaning 'bad air'"

On the wall was a poster with a long list of diseases, including a description of the etymology of each word.

"I have an interest in roots," Flora said. *"Whether it be the roots of illnesses themselves, or the words that we use to describe them. Did you know the story behind malaria, for example?"*
"I did not."

I scanned the other illnesses briefly, noting the names in case I needed them later.

RABIES
– from the Latin *rabere* meaning "to rave", named for the way it induces hyperactivity and frothing of the mouth.

CHICKENPOX
– medical name "varicella", possibly derived from the Latin word *varius*, meaning speckled or spotted.

MALARIA
– a disease caused by foul air from marshy districts. The name is derived from the Italian *mal aria* meaning "bad air".

MENINGITIS
– medical name of disease sometimes caused by recently discovered bacteria, *Neisseria*. Name derives from the Greek *meninx* (membrane – often refers to brain) and *itis* (referring to inflammation).

INFLUENZA
– named from the Italian *influenza*, itself derived from the Latin *influentia*, both meaning influence. Doctors originally believed it was an illness influenced by the position of the stars.

Clearly Aiden/Saren was leading me towards another one of his alphanumeric words. I was running out of time, and knew that I needed to figure out what he was trying to tell me.

Once I had found a word from solving the clues he had left me,

I KNEW I COULD PROCEED.

Neisseria. The sharp flash rocked through me, swaying me back and forth a few times. I fell to my knees, but I fought it, not quite wanting to depart just yet, and knowing I had some minutes to spare. Something had been bugging me.

"Are you all right?" said Flora.

"Just fine. It's not the first time."

"Maybe it's a sign of something more serious? Have you been feeling unusual in any other ways?"

"Many, but trust me, it's nothing for you to worry about."

"You do not wish for me to help you? How curious."

"I need to leave soon. Thank you for your help."

"Please, think nothing of it," Flora replied. She forced the smile of someone who was trying not to show concern.

"But I do have one question, if you are to go."

"Sure, what is it?"

*"The name **'Aiden'**. Jimmy said that you seemed surprised to hear it. Were you expecting something else?"*

"I guess I didn't realize my ... associate ... went by many names."

"Don't we all?" she joked.

"That's actually what I wanted to ask you about. Your name is beautiful, but it's not your full name, is it?"

"Oh, no, Flora is just part of my name. I was named after the Italian city."

Jimmy stepped forward excitedly to confirm.

"She goes by many names, too. Many people call her the 'Lady of the Lamp'. And of course, Flora, short for Florence."

"Florence? Nightingale?" I had half suspected, but I was still starstruck.

"Yes, that's right."

I wanted to stay and talk to this legendary figure but my earpiece started beeping faintly.

"What's wrong? Are you feeling worse?" Flora asked.

"No, but I have a feeling my time here is up. It has been a pleasure to meet you, and see your wonderful work. Just know that Aiden's mission was successful. I don't quite understand it all myself, but I can go home now and hopefully do some good there."

"It was my pleasure," Flora said, smiling.

I realized that I couldn't let them see me return to my time. Changing the past was something Saren had warned me about. I bowed at them both and backed out of the main doorway until I was out of sight, and then focused on the word: **NEISSERIA.**

A flash came again, and my ears seemed to pop as if the pressure was changing. I barely noticed that I had been clenching my eyes shut until I tried to open them and saw that I was back in the gallery.

Michelle raised an eyebrow. *"I assume you've been there and back again?"*

"Neisseria!" I almost shouted, desperately trying to avoid forgetting the word that until a few minutes ago had been absent from my vocabulary.

"Excuse me?" Michelle said, bewildered.

"The word … the word that brought me back here. It's what Aiden wanted me to find."

"Aiden?"

Things were getting confusing, and I had a lot to explain, but first…

"I suppose you should probably get me tested for infection?"

"How very eager of you," Michelle replied, squinting her eyes in suspicion.

"Well, if I'm honest, I think I was around a lot of people with airborne diseases."

"I do wish you'd be a little more careful."

She shook her head and quickly put her face mask on.

I assumed that Michelle was joking as she turned around and paced towards the medical half of the building, but her sharp tone and cold demeanour made me question that assumption. What did she expect me to do? They were the ones sending me back in time, after all! Shrugging, I removed the earpiece and followed her out of the door.

The doctor was already waiting, having said goodbye to me only a few minutes prior – in his perception of time. He ushered me into his room and I placed the earpiece into Michelle's waiting hand, after which she left to clean and charge it. I immediately started undressing to make Dr Soutar's job easier. I was already becoming familiar with the routine.

"A good trip, Adam?" he asked.
"Enlightening. Hey, do you know what Neisseria is?"
"Yes. It's a genus of bacteria. There are multiple types, but one can cause meningitis. Do you believe you are at risk?"
"Probably not, but for some reason someone wanted me to discover the word," I answered.
"And why do you think that is?"
"I don't know." I shook my head, confused at the whole situation. I noticed Dr Soutar approaching me with a needle. *"Another blood test?"*
"Every time."
"Can you detect infection this fast?"
"Let's just say you'd be surprised at the technology we have here."
"I just travelled through time – twice – I don't think I'm going to be surprised at anything for a while," I said. *"So, we're doing this all again? Got a spiked drink for me?"*
"I apologize for last time. But yes, you will need help sleeping."
"I only woke up a couple of hours ago."
"Exactly."
"Do I have to?" I begged.

"It's either that, in which case you wake up refreshed and ready for action, or you stay in here, unable to leave, waiting for test results to come back, and draining yourself before your next adventure into mortal danger."

"Your bedside manner is truly exceptional."

"Would it help if I spoke to you while I work, as you decide?"

"Please. I don't need to tell you how scary this whole thing is." I paused. "You know, I don't even know your first name."

"I'm Rhett."

"It's a pleasure to meet you, Rhett."

I realized I could not shake his hand, still contained as it was within the full-body hazmat suit. The ensuing awkward silence led me to want to start up a new conversation, but I couldn't think of anything to say. My mind kept drifting back to Calamity and Neisseria. Were these some clues I was meant to put together? Was there, or was there going to be, a calamity involving that bacteria? All of the worst-case scenarios ran through my head. Was I going to bring back some deadly disease from a past time period, and Aiden was trying to stop me?

The lethal negativity of the possibilities weighed heavily on me.

"I will take that orange juice, actually," I said quietly.

A couple of minutes later, I was asleep. It could not have come quickly enough.

CHAPTER 3

ANCIENT GREECE

My eyes opened, more calmly this time. The doctor was standing next to me, looking at a clipboard. I gingerly stood up. My throat burned. How long had I been asleep?

"Can I have a glass of orange juice?" I asked.

"With or without sedative? Because addiction is a real problem," Dr Soutar said, already pouring it into a glass.

"Dr Soutar?" I started.

"Please, Rhett is fine."

"Rhett, just how dangerous is what I'm doing?"

"Some might wonder why you didn't ask that until now."

"I guess I was just swept up in everything the first couple of times."

He looked me in the eyes. *"The technology has never failed."*

Reading between the lines, he didn't actually come close to answering my question; he just clarified that the danger didn't come from the tech. So what was the real danger? Not finding a way back? Infection in another era? Or just coming to some undesirable end while travelling? And what was the purpose of it all?

I looked up from finishing my juice to see Michelle waiting for me. Rhett motioned to follow her, taking my glass from me. Michelle took me to the main floor again.

"So is this how it goes until we're done?" I asked her.

"As in …?"

"Stressful adventure, straight back here to sleep and then right back into it?"

"Why, do you need to stop?" she asked, suddenly concerned. I couldn't help but feel the worry wasn't completely on my behalf.

"No. I just —" I began, *"is this it? When I'm done with this gallery, is my job over?"*

"I hope so. I'm not overly keen on sending employees into unknown and dangerous situations. It's not quite my job description."

"What exactly is your job then, Michelle?"

She paused.

"I am the head of special operations, which undoubtedly doesn't really answer your question. It is, however, the best I can give you right now."

"Fair enough." It was as much as I was learning about everything else going on around here.

"Have you been thinking about the words you have come back with? **Calamity** *and* **Neisseria.***"*
"I am convinced that Saren is trying to send a lengthier message. But why these eras? And do you think Aiden is Saren?"
"I think it's time to explain a little more about this place," Michelle said, walking on again.

I couldn't help but wonder why she hadn't told me more at the start. But then, perhaps I would have been less likely to take on the mission if I had known the full extent of it, or its dangers. I nodded expectantly at Michelle and she continued.

"The artefacts in this place were procured directly from a very special donor. Saren, or Aiden, or whatever his real name is, visited us — well, visited my husband, the head of Wexell. He had a number of items physically with him — at least one from each of these eras — and a list of others, which we have painstakingly assembled here for you to do what you must do."
"So, if he was sending a message, he would have just told Mr Samwell?"
"You would have thought so, but he was elusive about his intentions. Perhaps there was something stopping him from telling us directly."
*"***Do not change the future.*** That was his message to me in Egypt."*
"Our best guess is that changing the future has unintended consequences. The butterfly effect and all of that. Minimizing any alterations is of great importance when travelling through time."
"Then why leave all of his clues in the open in ancient Egypt?"

"What do you know of that time, Adam?" Michelle said, seemingly changing the subject.
"Probably less than I did when I was in school."
"Understandable. King Tutankhamun died young, possibly from some infectious disease. Plagues wiped out large swathes of the population. Where you visited was likely the epicentre of one of those events."
"So he could make alterations there because ..." I mumbled in realization.
"Exactly. It would not affect the future because they were all going to die very shortly."

I stepped backwards, struck dumb by the realization of the ultimate fate of all of the people I had seen there. Poor Nephthys.

"Don't get me wrong, obviously even those not wiped out by these diseases would be long gone by now," Michelle explained, *"but the common denominator may be the incapability of those you visit to pass on the information."*
"And Florence Nightingale? She didn't die that soon after I met her, did she?"
"I suppose not. But perhaps there is something else going on that's not clear. And at the very least the majority of other people there at that time may have died right after your visit."

"How morbid."

"Indeed. Up for continuing?" she said, all too briskly for my liking.

"I guess so. Just one thing..."

"What?" Michelle suddenly looked nervous. Was she worried I was going to back out now?

"When I was in London, I needed a pencil and paper to work some things out. I might not always have that where I'm going. Could you get me some before my next journey?"

Michelle's relief was palpable. *"Is that all? Of course, I will sort that out immediately. But for now, please come this way."*

Entering a new area of the gallery, the back wall was a huge fresco of what I assumed were five holy figures.

"I see you're drawn to the largest artefact we could procure," Michelle noted.

"It's massive."

"It's from a wall on the side of the Church of Protaton in Karyes on Mount Athos."

"How did you get the whole wall here?"

"Oh, unfortunately it's just a replica. There are some things that even we can't – or don't want to – do," Michelle laughed.

"If you guys went to so much work to make this, why not restore it fully?"

Michelle paused again, seemingly unsure. *"We don't know whether the imperfections are what we need to be looking at."*

I looked back at the fresco. Perhaps Michelle never thought to restore it, as the imperfections certainly didn't seem to be important to me.

"Have you seen the real thing in person?" I asked.

"No. The entire island remains one of the few places in the world that women are banned from."

I laughed. When I realized that she was being serious I blurted out. *"Why? What did you all do?"*

I cringed at my attempt at a joke, but fortunately she smiled, which was a great relief.

"We assumed it was important as we found the coordinates to the location on a piece of parchment that was wrapped around the actual artefacts that were delivered to us."

Michelle pointed over at an arrangement of variously coloured helmets.

"Did you arrange them in this order?"

"We followed the description on the parchment. They all came from Naxos."

"And what are the symbols on each helmet?"

"As far as I'm aware, the symbols are ancient Greek numbers, but they worked a little differently to ours. The Greeks had a letter from their alphabet for each number, but the positioning of the numbers was important. For example, 'E' would be 5, but if you needed to say 55 you wouldn't say EE. 50 is N, so you'd say NE."

"And there would be a different character for 500?"

"Exactly. That would be a phi, which looks like a circle with a line through it," she confirmed. *"900 is as high as it goes. However, If you want to depict thousands, you start from the first symbol again and just put a little comma before the number to indicate it is that number times 1000. Some characters look the same as our current letters. Some, like sigma – that's kind of a capital E-shaped zig zag – don't, but still developed into our letters, in that particular case, S."*

A central podium caught my eye, with what looked like a Grecian urn on it. The pattern of warriors designed around it was beautiful. I looked over at Michelle.

"Crete. The full image is replicated below," she said. I assumed that was where it had come from.

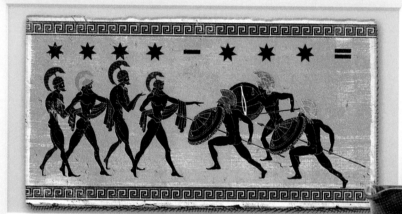

Elsewhere, a striking framed plate depicted more battling. It struck me that the majority of ancient Greek art seemed either to depict people fighting with each other, looking pious or just lounging around naked.

There were letters and symbols running around the outside of the plate, which I assumed was the ancient Greek alphabet that was also used for counting, as Michelle had described. It didn't take a rocket scientist to guess that it started with A and ran clockwise around the plate. A few familiar-looking items were placed suspiciously around the plate too, with lines linking to the characters. The whole artwork seemed busier than it should be, and I guessed that they were there for my benefit, rather than artistic merit.

"And that one is from Paros," she stated blankly.

I nodded. This was it, then. I needed a year, which was probably around 2,500 years ago, and a place I was heading.

Once I had both of those pieces of information,

I KNEW I COULD PROCEED.

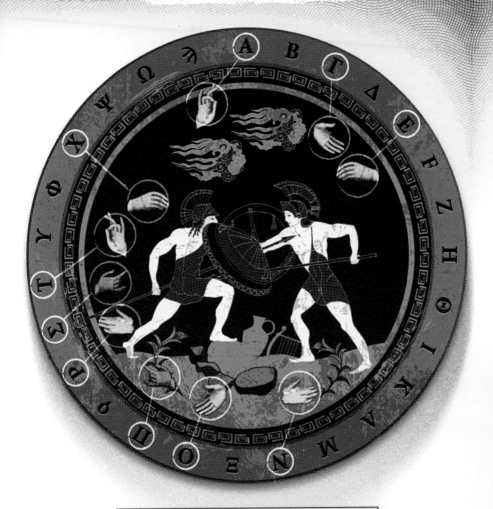

671 BCE, Naxos,

The sharp sting descended through my body once more, but I was expecting it this time. It was easier now for me to fully embrace the exhilarating feeling of time travel without shying away from it. The electrical pulse felt like it contained me; it was a wave that took me with it without having to feel a physical movement, a bit like a thought suddenly turning into something new and original.

I eagerly opened my eyes – closing them was a seemingly involuntary part of the process. I could see rich blue waves lapping under the cliffs on which I was suddenly standing. An awe-inspiring view, but one that caused me to step backwards quickly, stubbing my left heel on a rock before falling over myself into an embarrassing heap. I was suddenly aware of a cacophony of sound, topped off by something that sounded suspiciously like laughter.

I gathered myself and turned around to see what looked like a market. Stalls and stands with fresh food, linens, vases and all manner of items for purchase ringed a courtyard, which I vaguely remembered from my studies was called an *agora*. I stood with my mouth open in wonder, overwhelmed by the glimpse of history that I was privy to.

The occasional passer-by spotted me, looked shocked, and looked away. What was incredible to me may have been everyday to them, but I certainly was not. Perhaps it was the clothes I was wearing. They were quite different from the long, flowing robes and fabrics worn by the locals.

I decided it was wise to try to fit in, though without any way of paying for anything, I couldn't expect to purchase something at the market to dress myself any less conspicuously. I wandered between two stalls to get a better view of the main thoroughfare and a fast-moving blur struck me as it flew past.

"Fig appa messy", or something closely approximating it, was all I caught from the man who had been running past. He was holding a surprisingly large piece of meat – perhaps stolen, given his pace? – and in our collision had dropped a piece of material, paper of a sort. It had a word written on it.

A woman in beautiful apparel with curly golden hair ran after him. She looked over at me for just a fraction of a second, but it was long enough for me to feel like she had clocked me as an unusual bystander. A few steps later, she stopped and looked back around, directly at me.

She put her finger to her lips, nodded and then continued to chase the thief.

I couldn't help but think that she knew who I was. Perhaps she had already had contact with Saren? It was the only thing that made sense of her reaction. I waited until the commotion was over, and then walked back towards the *agora* in the hope that she would return.

There were five food stands that looked like they were permanent fixtures and stood out as particularly impressive to my modern eye. The first stand I came across had baskets and baskets full of olives, each smartly labelled with what I assumed was the city or town they came from.

Similar stands next to the olive-seller showed various types of salt (which, from the vast quantities on offer, seemed far more important to this older society than I had expected) alongside their places of origin, and wine, contained in unusual two-handed jugs with pointy bases fixed atop a series of wooden shelves that must have been specially built to hold them.

ΠΕΡΖΑΜΥΜ

ΛΕΣΒΟΣ

ΙΛΙΥΜ

ΗΑΛΙΓΑΡΝΑΣΣΥΣ

ΝΑΧΟΣ

Next, I came across a stand with what looked like fresh meat. The owner was in vigorous conversation with a number of people around him, gesticulating wildly and obviously pretty angry.

ΓΟΡΙΝΤΗ

ΑΝΔΡΟΣ

There was an empty space on his stall, I guessed left by the hunk of meat that I believed to have been stolen.

ΣΑΜΟΣ

Near to the meat stall was a stand with a selection of pungent cheeses that actually made my mouth water. I wasn't really hungry, but while questionable raw meat was hardly appetizing, this stand would have made a customer of me if I had the means to pay (and didn't want to risk messing up the future).

I even instinctively began to look around for somewhere that sold bread, before realizing that these distractions were unwise given the ever-ticking clock of my earpiece's battery.

ΑΝΔΡΟΣ

ΠΑΡΟΣ

ΛΕΜΝΟΣ

ΝΑΧΟΣ

ΗΑΛΙΓΑΡΝΑΣΣΥΣ

With no other objective in sight, I decided to explore the wider market area, but stayed close enough to the *agora* that the woman who had passed me could still find me if she needed to, as I suspected she did. Fortunately, I stood out, not just because of my modern clothes, but also simply by being taller than everyone else I could see. While wandering among the various food stalls, I was struck by the realization that modern nutrition was responsible for me seeming like a giant in these historic societies.

Before I could begin to muse on this any further, my eye caught a flash of colour: deep-red banners stretching high along some pillars. I followed them through an archway that led to an enormous open area; an amphitheatre with seating curved up and around it. The centre had around a dozen people rehearsing what looked like a play interspersed with an unusual form of dancing. The actors kept repeating specific tableaux over and over, freezing in place in different formations; their precision was impressive.

"It will be majestic, will it not?" spoke a voice from behind me.
"I have never seen anything like it," I admitted. It was the woman from earlier, her clothes and gentle movement almost making her appear to float.
"I thought you were who I was waiting for," she said. *"I was right."*
"Was there someone before me?"
*"There are always people before us, and after us. But I believe you are speaking of **Orfio**. He was with me for a few glorious weeks."*

Was this Saren's assumed name here? Something was odd about this encounter, but I couldn't put my finger on it.

"My name is Adam."

"They call me the Cyphstress," the woman said.

"Your parents must have been cruel," I joked.

"Hardly. You may notice there are very few other women around here."

I hadn't, but now she pointed it out, she was right. It was clearly a very male-dominated society, and it was my own failing for not noticing this.

"Generally, a woman's place is in the home. They taught me to be... different. I am the one that breaks the rules."

That was an odd way to put it, I thought. I suddenly realized what was bothering me: the Cyphstress spoke English almost perfectly, except for that last phrase which sounded garbled, almost like it had gone through Google Translate. Yet she had only interacted with the other traveller for a matter of weeks? Surely that was impossible.

"I seem to be meeting a lot of those sorts of people at the moment."

"From a young age, I've been interested in the way the world fits together, extrapolating ideas from what I observed. It has made me useful in my work on the side. I track down criminals for influential families."

"You're a police officer?"

"More of a consultant."

Again, more perfect English. And how would she know what a police officer was? I put my concerns aside to think of later, and looked back at the performance taking place in front of us.

"Orfio worked very hard to create what you see there."

"Wait a second, this was Orfio's show?"

"Yes," she said wistfully. *"He was very clear with his choreography. I only wish he could still be here to see it."*

My focus returned to the performance as it restarted; it had to be important. Ignoring the Cyphstress's wondering glance, I took out my pencil and paper and quickly sketched the positions of the dancers as they moved from tableau to tableau, numbering them from 1 to 5 in the order they appeared.

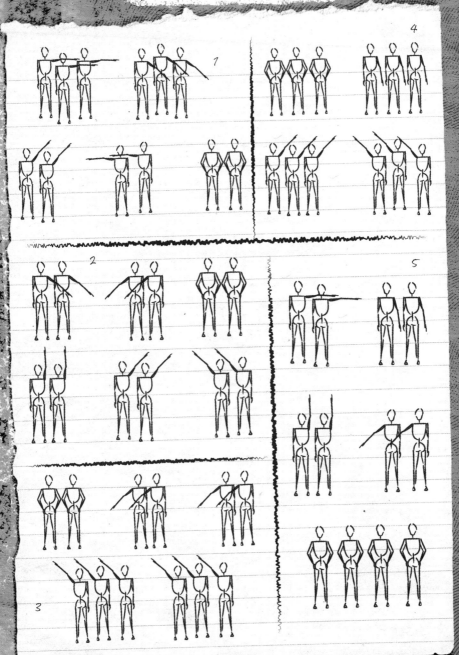

"It seems quite unusual to me," I said, as the dance came to a close.

"To me as well. The organizers were very keen to have outside voices produce art for the festival, which gave Orfio his chance to teach us this dance from his homeland."

"There's a festival going on?"

"Indeed. You think we have the variety of food you saw in the market every day?"

I had no real idea what was commonplace for people in different time periods and countries, so I shrugged and tried to look wise.

"What else did the person who came before me leave?"

"Orfio?" she asked.

"Yes. There must be more, if he has left this."

"You seem to know a lot about him. Yes, he was rather involved in the design of the entire festival and what exactly would be taking place around the city. In fact, he drew a map of it. Let me take you to where he was staying."

I nodded, eager to see more of his clues.

My adventure was never meant to be about sightseeing, yet as we walked through the city I couldn't help but be wowed with every step I took, not least because for the first time on my travels I didn't feel myself to be in immediate danger. There were no guards locking me up and no autopsies being performed nearby with questionable hygiene. There were just the incredible sights that nobody else from my time would ever get to see. As the breeze blew through the streets, carrying the unpolluted seaside air and cooling the otherwise glorious heat of the place, I could even let myself believe I was on holiday.

Then I began to count down the minutes I had left to safely make it out of here ... and started thinking about that danger again. If we had to walk much longer, I would have almost no time to solve the next puzzle. Fortunately, my new friend stopped in front of a rustic-looking entrance and pushed the door open.

"In here."

I walked in to find a huge collection of bottles, papers and miscellaneous items that seemed like they could have been ripped from a witch's hut in a fairy tale. Bathed in the golden light from the windows, I shook off any sense of foreboding. This was a blend of myth and science. On the far wall was a map of the city, if indeed it was large enough to be called one. An X in the centre showed, I assumed, where we were, and roads leading up, down, left and right sprung out from each junction in a block pattern that I was not expecting. Each junction had a number written on it.

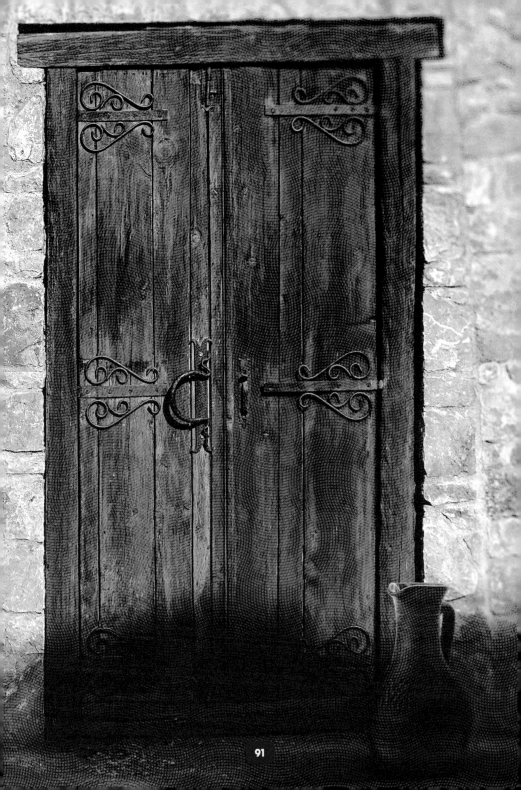

After a brief moment studying the map, I was interrupted by my new friend offering me some sustenance.

"I have many things here – breads, cheese, wine. What would you like?"
"That's very kind," I began, *"but I ate before I arrived."*

While time was certainly on my mind, I was more worried about the possibility of changing the past, or catching some ancient stomach bug. I hoped that I had not offended her, turning down something that was undoubtedly a valuable commodity to her.

"Of course, I understand. Orfio, too, never ate in my presence. You foreigners have some strange customs! Please do let me know if there is anything else I can offer you," she said warmly.

As relieved as I was not to have damaged my relationship with my new companion, I could not dwell on it. It had dawned on me that everything here could be a clue to the alphanumeric code I was looking for. Perhaps I shouldn't refuse anything else – it all might be important.

"Is there anything else you think I should see?" I asked her. *"Anything Orfio left behind?"*
"Yes, there is one more thing."

The Cyphstress dragged a large dusty trunk that was nestled under a table out into the centre of the room. A few quick locks were undone and then it was open. As impressed as I was with the intricacy of the trunk's design, the drama of opening it up – light shining in on it from the window and a cloud of dust rising up as it creaked open – was enough to make my eyes widen. She reached in and pulled out a rolled-up paper tied with a red cloth, before untying it and rolling it across the floor. She reached back into the trunk and brought out four bronze effigies that looked like Greek gods, placing them on each corner to keep the map open.

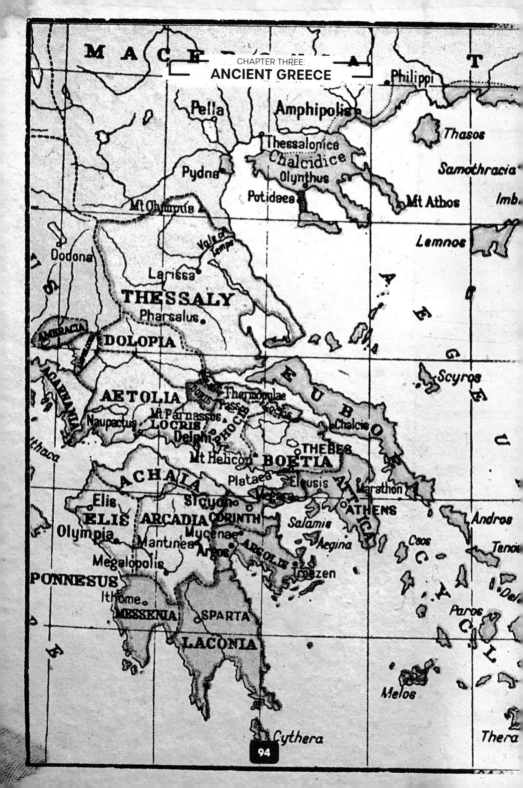

M A C E — — A T

Philippi

Pella

Amphipolis

Thasos

Pydna

Thessalonica
Chalcidice
Olynthus

Samothracia

Potidaea

Imb.

Mt Olympus

Mt Athos

Lemnos

Dodona

Vale of Tempe

A
E
G
E
U

Scyros

Larissa

THESSALY

Pharsalus

AMBRACIA

DOLOPIA

ACARNANIA

AETOLIA

Thermopylae Pass
LOCRIS

EUBOEA

Naupactus
Mt Parnassus

PHOCIS

Chalcis

Ithaca

Delphi

Mt Helicon

THEBES

BOETIA

ACHAIA

Plataea

Eleusis

Marathon

Sicyon

Megara

ATTICA

ELIS
Elis

ARCADIA

CORINTH

ATHENS

Olympia

Mycenae

Salamis

Andros

Mantinea

Aegina

Ceos

Tenos

Megalopolis

Argos

ARGOLIS

PONNESUS

Troezen

Ithome

Delos

MESSENIA

SPARTA

Paros

LACONIA

C
Y
C
L

Melos

Cythera

Thera

It looked like a map of the Aegean Sea, surrounded by Greece and Turkey, with the place names written in Latin and Greek. They were organized rigidly, and though their placement may not have been 100 per cent accurate, I wondered whether they were rendered this way for another purpose. This map was the key to linking everything else together.

"Do you know what you must do?" the Cyphstress asked.
"I have no idea," I admitted. *"But I guess I'd better get started."*
I thought back to the moment when I arrived here, and of everything that I had seen and experienced until now, eager not to forget anything important.

I needed an alphanumeric code, a string of numbers that would give me a word I had seen somewhere.

Would this be my token?
Once I had it,

I KNEW I COULD PROCEED.

Ilium. That was one of the cities on the map. Was that my token? I concentrated on it, and yet nothing happened. Then I spoke it out aloud.
"Ilium." Again, nothing. This wasn't good. Had I gone wrong somewhere?
"Ilium?" the Cyphstress asked.
"It's important, that place. At least I hope it is. But I don't know why."

Suddenly, I heard a tiny beeping in my ear. Every couple of seconds, my earpiece was giving a little chirp.

"Can you hear that?" I asked.
"Hear what?"

My earpiece was trying to tell me something. Not that I was correct; I knew how that felt. Nor was it telling me that I was wrong — the myriad other words and thoughts I had had during my investigations were never acknowledged. I could only think of one thing, and I didn't like my conclusion: a low battery. I was running out of time, and fast. I needed to find my token or I would never find get home.

"I need to figure this out. It has to be 'Ilium'. Everything leads there."
"I do not understand," the Cyphstress said helplessly.
"OK, let's talk this through. What is Ilium?"
"It is a city in Tourkia."
"Tourkia ... Turkey."

Right. The fact that place names are often different in different languages is an easily forgettable feature. London in French is "Londres", for example. So was Ilium something else? The beeping seemed to increase in speed.

"What else is Ilium known as?" I pleaded with my new friend, trying not to sound too desperate.
"Ilium is Latin... it is also Ilios ... Ilion ... Troia."
"Troia? Like ... Troy?"

I felt a subtle pulse of energy. I had to be close. It wasn't exact, but I was nearly there.

"Yes, Troy. That is what we Greeks call it," she said.
"Why is Troy so important?"

"Is this something I am supposed to tell you?"

"I don't think so. It needs to mean something to me, or at least to people in my time, to make the connection."

"Your time?" she said with a stutter, confused.

The beeping grew faster still.

"Sorry, it's difficult to explain." I excused myself from the tough question. *"But I still need to understand what is important about Troy."*

"Well the most important connection to Troy that I know of is what we call the Trojan War. The stories about it are told within The Iliad, *created by Homer."*

"The Iliad. Of course. Ilium... Iliad. Etymologically speaking, that makes sense."

"So what is it about the Trojan War? Do you know about this?" she said.

"Yes. Of course."

"And what do you know of it?"

"Nothing, really. Hang on. It wasn't just Homer that wrote about the Trojan War. I remember from The Aeneid *by Virgil..."*

"The Aeneid?" she asked.

"Oh, right, that hasn't been written yet ..."

"What??"

The beeping became a single flatline. My time was possibly seconds away from being over.

"Look, the story I remember is about how the Greeks hid themselves in order to sneak inside the walls of Troy and attack from within, unexpectedly."

"What is this of which you speak?"

"My strongest association with Troy. The story of the Trojan horse."

Crack. A snap of electrical energy burst through my head, cascading down my body, leaving me out of breath.

"That's it." I breathed out with relief. *"I have to go. I have no more time."*

"It was my honour to meet you, Adam."

"And you. And I have to say, your English is fantastic."

I smiled at the Cyphstress, focusing my mind on the words and concept of a Trojan horse. A dark wave came across me. As I felt myself begin to float through what felt like an internal portal, I heard her last words to me.

"But I don't know what English is, Adam."

I had collapsed in a heap, as I discovered when I came to.
"Did something go wrong?" Michelle's now familiar voice welcomed me back to my own reality.
"Michelle?" I felt disoriented and confused. Michelle was walking towards me from the other side of the gallery — not from where I left her. *"What is going on?"*
"You've been away for eight days. We thought we'd lost you."
"I don't understand."
"Nor do we. What happened?"

I racked my brain. The only difference was how close I had got to failure.

"I nearly ran out of time. The earpiece started beeping and then ... I can only describe it as flatlining."
"You were lucky. The flatline must be the final few seconds before it doesn't have the power to return you," Michelle said, now close enough to help me up. *"I assume you succeeded though?"*

I reached up, in a request for help, but Michelle wouldn't touch me. Clearly, I needed to be tested for contamination.

"I found the token. It was something that wasn't even from that time. Centuries later. Something only I could have known about."
"And was everyone there similarly ..." Michelle paused, searching for the most tactful phrase, *"... doomed?"*
"I don't think so. I didn't see illness or anything suspicious that could have wiped them all out."
"Perhaps we are heading towards more positivity, then?"

I smiled and tried to get my footing to stand up. Instead, I found that I could not hold myself up at all and I collapsed back to the floor. Michelle flinched, itching to help me, but clearly following procedure.

"Positivity. Yes," I agreed.
"So, the token?" Michelle asked
"Trojan horse."
Michelle stepped away, clearly even more concerned for her safety. The words meant something to her that I was missing. I started breathing faster, almost hyperventilating.

"What are you doing?"
"Adam, I don't think you have comprehended the significance of what you have discovered. What is a Trojan horse?"
"A surprising attack. Something bad coming in an unexpected form."
"Are you sure you didn't come across anything suspicious? Did you eat anything while you were there?"
"No. But I don't understand why you are so concerned now."
"Because we now know what form the calamity will come in: a bacterial infection."
"Trojan horse ..." I finally understood. And it hit me with a devastating force. *"I'm the Trojan horse."*

And with that, I lost consciousness.

CHAPTER 4

RESTORATION

I opened my eyes and, vision blurry, looked down to see Dr Rhett Soutar in his hazmat suit at the foot of the bed I must have been taken to. My arm was throbbing from whatever tests had been performed on me. I tried to speak, but couldn't, and ended up having a coughing fit instead.

"All clear," Rhett raised his voice over my spluttering.
I was, naturally, relieved at this announcement — but still groggy and confused.
"But I am the Trojan horse," I struggled to say.
"As far as we're aware, you're not. And I don't think that's the point."
"No, that's what it said. My token."
"Did it say that? Are you sure you're understanding the message?"
"I guess not," I said, leaning back into my bed.
"All I can tell you for certain is that according to all modern science, we cannot detect any significant foreign substance in your system at all."
"Then why are you always wearing that suit?"
"There is no sense in being reckless now, is there? And it kind of goes two ways. If you got something from me, and took it to another time zone where they were unprepared for it, it could cause devastation beyond what any of us could predict."
"I suppose so."
"Now, we have an unexpected surprise for you, Adam," he said.
"Could you handle a visitor?"

I nodded, both excited and nervous for whoever it was; they'd have to both know I was here and have the clearance to be allowed in, which meant they would have to be important. The doctor nodded to the doorway and a happily familiar face entered.

"Adam, I'd normally say you're looking well, but wearing a hospital gown in bed really doesn't scream 'healthy' to me," said a voice I recognized.
"Henry?" I replied.
"I'll leave you two," Rhett said, as he exited the room.

Henry Fielding, a great friend of mine — who first got me into this mess by causing our initial adventure with The Wexell Corporation — strolled in, seemingly unconcerned about any risk of being in contact with me. This was very much in character. He was something of an "act first, think second" person, and before I could say anything, he leaned in to hug me.

"I'm proud of you," he said.
"Thank you. It's been a very strange 24 hours."
"It's been longer than that."
"Of course it has," I corrected myself. *"So what are you doing here?"*
"Can't a guy just pop in to see his friend in case he dies horribly in some horrendous other time era?"
"Well, when you put it like that ..." I laughed.
"The truth is, we figured you may have more questions now than you would have done at the start of it all, and Mr Samwell, Wexell's CEO, has 'opened the books' a bit, so to speak."
"What can you tell me?"
Henry paused, smiling. Clearly he was weighing up what he wanted to volunteer. *"What do you want to know?"*
"Who is Saren?"
"Ah, yes. The traveller you have been following around. The man who gave us the initial artefacts."
"Yes. Him. Who is he?" I pressed.
"I honestly don't know. We don't know. He's not someone from Wexell who has been using our technology — at least not someone from the past. We assume he has come from some point in our future, to help us. Or warn us."
"He's not me, is he?" I half-joked. *"I'm not going to learn something that means I have to set up all of this stuff for myself to solve in order to repeat in an endless cycle, am I?"*
"It's exactly that kind of outside-the-box thinking that got you this job, but no. I've never met him, but Mr Samwell has, and he would have recognized you from when he met you to offer you this job. And it's not in his interest to hide information like that from insiders."
"Then what do you know about Saren?"
"He arrived, gave us the artefacts and ... disappeared."
"Disappeared? Like, travelled back to where he came from?"
"I don't know. Just ... disappeared. That's the word Mr Samwell used. That's all I know."
"So what about what I'm actually doing here?"
"You know as much as me. Follow the clues. Find the tokens. Learn what we're supposed to know."
"I still don't understand why Saren wouldn't just tell us."

"I assume it's about changing the future," Henry said. *"To change the future, you have to do it in the right way. Think of the whole 'stopping Hitler' idea that people always talk about. Imagine you were able to go back in time to when Hitler was a child and, I don't know, get him obsessed with baking instead of politics so that he never caused war, and is therefore removed entirely from any meaningful history."*

Henry paused to check I was following along. I nodded.

"So, as time continued, the 'future' you would have no reason to go back in time to stop him – he's just a baker – so you would not go back in time. It creates an unresolvable paradox."

"I think I get it," I said, although I wasn't too sure. *"So, in order to successfully change the past, you can't change the reason why you changed the past in the first place."*

"Exactly. Otherwise, if you solve the problem, then there's no need to solve it."

"But then, what's the use? How can it be done? And what calamity is this warning referencing? If we're receiving the warning, surely it's hopeless to try to avoid it."

"We don't know. But there's only one way to figure it out."

"Yeah, yeah. I guess I'm going back in time again." I sighed.

Henry smiled at my nonchalance at travelling through time, then seemed to remember something, and started inching towards the doorway.

"Look, I'd better head off and leave you to your work. I've got to get back to the hospital."

"Hospital?"

"Nothing for you to worry about," he said, smiling.

And with that, he was gone. I wearily got up, put on some clothes and returned to the gallery in time to catch Henry talking to Michelle in hushed tones.

"I'll send him your love," Henry whispered.

Michelle nodded – were those tears in her eyes? – and Henry departed, looking back and giving me a wave on his way.

"Ready for some more work?" Michelle said with a quick smile.

There were far too many forced smiles around here for my liking.

"Is everything all right?" I asked.

"Absolutely fine. Now, I suppose you're wondering what is ahead of you this time."

Before I could react, Michelle had walked over to a new section of the gallery.
"Stupid question," I started. *"but I'm not leaving this gallery until this thing is over, am I?"*
Michelle held my gaze in silence for an uncomfortably long time.
"I'm sorry."
"No, that's okay. I appreciate your candour. I don't really want to stop."
"I'm pleased to hear that."

Turning to the new gallery area, I was faced with a plethora of items. Most of them seemed European in style, but beyond that I couldn't see a natural link.

"Stupid question again ... surely with the art you've got here, dating them shouldn't be too hard for an art historian? All of the others were from a particular time period."
"We don't think it's the date of the art we need. It's the date somehow hidden within them. We believe all of these items are from different years. Some even centuries apart."

My great idea to save us some time had been struck down before I'd even started. Despite all of the lavish pieces before me, my eyes were first drawn to a small porcelain cat.

"An interesting design," Michelle noted. *"It always freaks me out when I see art with faces that have the eyes poked out. Apparently that was part of the purpose of the cat. You would put a candle inside, and the light would shine out of its eyes, almost like a night light. But also to scare off rats."*
"Charming." I was already expecting a plague of vermin to be awaiting me at my next destination. *"And the holes on the ears?"*
"They are not normal. Perhaps this one was made especially for this gallery."

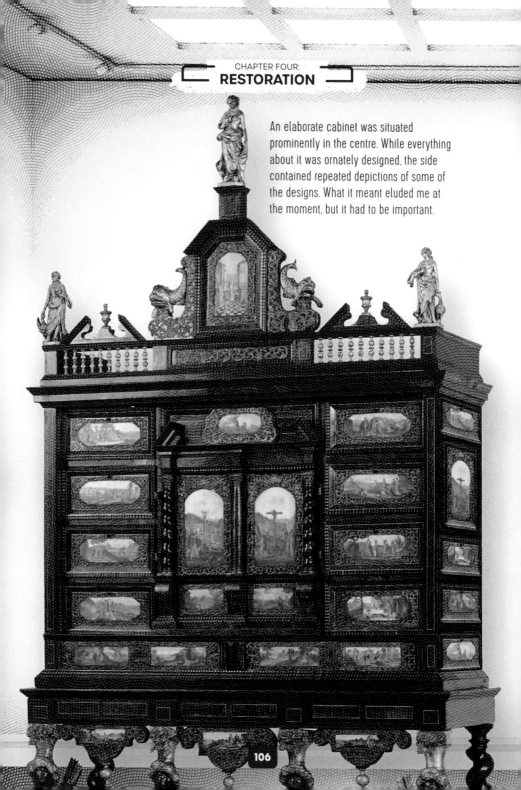

An elaborate cabinet was situated prominently in the centre. While everything about it was ornately designed, the side contained repeated depictions of some of the designs. What it meant eluded me at the moment, but it had to be important.

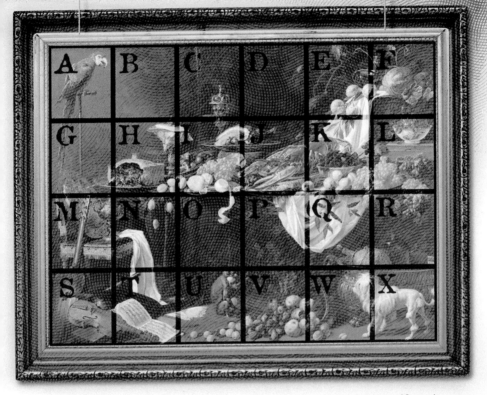

Suspended in the centre, looking somewhat out of place, was what appeared to be an A3-sized sheet of transparent acrylic. It had lines over it in a grid pattern, and printed letters that didn't look particularly like any artwork I'd seen before.

"What's this about, then? Some sort of ... modern art?" I queried.
"That's something we found with the artefacts, with instructions connecting it to that painting."
I looked over to see a detailed mishmash of different items. It was a fantastic piece of work, but my first instincts were to discard the floating hanging acrylic as unimportant.

"So how's that related to the painting?" I wondered aloud.
"Stand over there," Michelle ordered, pointing to the floor just behind the floating sheet.

As I stood in place, the grid aligned perfectly with the painting. It was a way of splitting the picture up and marking the image without damaging the artwork itself. Clever.

What looked like a tapestry filled with a strange floral pattern hung against the wall. It was disturbing, like it was looking at me with dozens of eyes, and while it must have been here for a reason, I couldn't get away from it fast enough.

A painting hung further along the wall, depicting a man in front of a table and a chest with some symbols on it. A dog was looking up at the man, and I paused to look more closely at it. It was staring at the man, likely unaware of the meaning of anything that it saw around it, but still looking. For a second it reminded me of myself ...

However, I couldn't help but notice the table had a line of items on it that seemed to be positioned very specifically. I felt like I was on to something. Perhaps I wasn't the dog.

"What's this from?" I asked, pulling at a small piece of paper that was tucked behind the painting.

"I'm not sure," Michelle admitted.

Studying the paper made it clear that it was related to the items in the gallery. Three lines suggested there were three words that I was looking for to reveal the location, on top of the year I would be heading to.

Once I had figured them out,

I KNEW I COULD PROCEED.

A	B	C	D	
				E
F	G	H	I	
				J
K	L	M	N	
				O

E		L		N
P				B
	I	O		
R				K
G		T	D	Y
A		M	S	F

1667, London, Theatre Royal.

I closed my eyes and prepared for the now-familiar pain. It happened swiftly this time, and I opened my eyes to see a woman alone on a stage, in a tight corset and long skirt, performing a monologue. Knowing by now that everything could be important, I pulled out my pad of paper and started scribbling.

Amphe.
How has my tongue bely'd my two ginger
Heart, in speaking hate unto the Duke and love to Ortellus.
I hate the Duke, so Eyes do sleep that long have known
No rest, how cou'd my Lips give passage,
To such words and not have clos'd for ever.
Not by my hearts direction I am sure, for
That so swel'd being injur'd by my
Mouth, as had not Pride and reason kept
It here from this unquiet seate, it wou'd
Have forc't away to Archimedes Breast,
And there have whisper'd to his heart my
Tongues untruth. Why shou'd I love this
Man, that shews me nothing but Contempt,
And hate: Rouze drooping heart, and think
Of that, think of it alwaies, so by degrees,
'Twill bring a Winter round thee, that in
Time shall Chill the heate of thy undone
And lost affections, oh 'tis four sugar that all our
Sex Love Change, then I might find one
Path that leades to it, that womanish vice,
Were vertue now in me, 'twou'd free my
Heart; and that were Charity.
Enter Duke.
Three seed where he comes again, oh how I love
And hate that man. Now help me Pride and fil
My Breast with one meat pie, and prethee Tongue
Take heed you do not faulter, heare not
My heart that will distract thy speech, and
So betray my fain'd unkindness.

As she paused to draw breath, a voice interrupted her from above.

"Look out!"

A huge slat fell down from the grid of rafters above us and narrowly missed the woman. Shocked, and no doubt a little angry, she raced offstage. Looking up again, I noticed the grid seemed to be half-finished with numbers painted above the missing pieces, perhaps as some obscure instructions. A man in the end seat of the front row — the only person in the auditorium other than me — stood up from writing in a small book, looking worried, before he noticed me sitting behind him.

"Oh, I didn't see you come in. Are you the director?" he asked.
"Me? No. I'm just a visitor."
"Then we are both the same. My name is Samuel."
"I'm Adam. It's a pleasure."
"You certainly have an unusual get-up."

I looked down at my clothes, a little surprised that they hadn't drawn more attention in other eras before now.

"Where I'm from, this is considered normal."
"I have no doubt. You remind me of a gentleman I met merely a week ago."

Instantly, I knew who he meant: **Saren**.

"His name was Artur. I don't suppose you know him?"
"I think I might."
"He barely spoke to me, but if you are looking for him, I would ask pretty, witty Nell. They spent some time together."
"Nell? As in ... Nell Gwyn?"
"Yes, that was the actress on stage just now. Perhaps you were shocked to see a woman on stage?"
"Absolutely scandalous," I joked. It landed on deaf ears.
"Well, then you need to get with the times, boy."
Nell came back on stage and called down to us.
"Samuel?"
"I am here," he replied.

"Did you know they were still repairing the theatre today?"

"I did, I am afraid."

"And who is this?" she demanded.

"This is Mr ...?"

"Adam Parkinson. Adam is fine."

Nell looked me up and down, and paused.

*"You must be with **Artur**."*

"In a sense."

"He helped me with this script. Anyway, nice to meet you."

And with that, she was off. Samuel watched her leave and turned back to me.

"The theatre is having a lot of work done to restore it back to how it was before the fire," he said.

"The fire?"

"The fire, yes. Of course, the fire. Where are you from that you didn't hear about the fire?"

"The ... Great Fire? Of London?"

"I feared for a second that you did not have newspapers where you are from."

I chuckled nervously. I would have to be more aware if I was to avoid being found out.

"Apparently, the whole thing started in a bakery in Pudding Lane. You heard that, right?"

I had learned about this in school, but thought it was time to move the conversation on before my lack of general knowledge about this time period gave me away.

"I heard rumours," I said, vaguely.

"Speaking of bakeries, there is a rather good one just opposite the theatre, if you are peckish?"

"Certainly." I nodded with relief.

Samuel moved to leave, and I followed him outside. As we passed through the foyer, I saw a large poster for *All Mistaken, or The Mad Couple* by James Howard. In large print underneath the title was written **"Starring Charles Hart and Nell Gwyn"**.

All Mistaken, or The Mad Couple

Written by the honourable James Howard, Esq.
Come, marvel, restore, enjoy.
Directed by James Howard, Esq.

Acted by His Majestyes servants

CHARLES HART

&

NELL GWYN

at the **Theatre Royal**

"Nell said Artur helped with the script for the play?" I asked.

"Is that a question?" Samuel replied.

"What I mean is, it says it was written by James Howard."

"Yes. Nell was never taught to read. Artur assisted her by reading her parts to her so that she could learn them by ear. An extraordinary achievement to learn all that without ever reading a word, really." He looked towards the book he was carrying and his voice became full of emotion. *"Of course, the irony of my writing about her is not lost on me."*

It confounded me that there was a time when the mere act of reading would be a skill that would not have been offered to everybody. We left the building and the smell of London hit me. It was an altogether different one to when I had been there centuries later; dirty still, but in a raw way, as if on my previous visit in Victorian times they had tried to mask the smells that were now just accepted. I looked over at Samuel and spotted a few flowers jammed in his front jacket pocket. He tapped them and smiled at me.

"You can never be too careful."

The flowers — could they be to hide the smell? But why was he talking about being careful? I didn't want to give away my ignorance again. As we approached the bakery, we skirted around a few children singing and dancing around in a circle.

"It is nice to see the children unafraid again, isn't it?"

"The fire must have been terrifying," I offered.

"Oh, the fire is why they are playing, my friend. It put an end to the Great Plague."

The plague? Another illness! And the flowers must be to ward off the "bad air" that they thought caused it.

"Hang on a second."

"Excuse me?"

"Perhaps that phrase didn't quite translate. I mean, you said that the fire ended the plague. How, exactly?"

"Well, because the fire destroyed a large amount of the dirtiest, most rotten buildings. In doing so, it burned away the dirtiness that caused the smell," Samuel explained confidently, tapping his flowers again.

I didn't wish to correct him on the flowers, and I guessed that the fire must have played a part in helping to stop the plague in another way. Perhaps it stopped the vectors of transmission, by displacing and killing rats and their fleas. Either way, I was glad I wasn't here a year ago — I couldn't imagine what it would have been like if the smell back then was worse!

"Here we are," Samuel announced, pushing the door open to a much more pleasing smell.

A sign with details of the items available towered over a large stone oven that seemed to be built into the wall. It included an unusual spelling of the word "biscuit", which must have been just how it was written nearly half a millennium ago. I was confused by the different denominations in use. Nothing I hadn't heard of before, but it was a long way from the simple decimal system I was used to.

Menu

Seed cake — 1 farthing

White Bread — 1 farthing

Brown Bread — 1 farthing

Raisin Puff Pastry — 2 farthings

Sugar cake — 2 farthings

Honey cake — 2 farthings

Italian Bisket — 3 farthings

Ginger-bread — 3 farthings

Meat pie — 1 penny

Box of 12 meat pies — 2 groats

Suckling pig — 3 shillings

Party catering — prices from 2 crowns

Year's supply of flour — 1 pound

"Not from around here, are you?" the baker guessed, seeing my confusion. *"Well, it's really quite simple. You get a farthing, which is a quarter of a penny, then a groat, which is four pennies. Three groats make a shilling, otherwise known as a bob, then five bobs are a crown and four crowns are a pound. Easy, right?"*

I realized quickly that, even if I could figure out how much everything cost, without any money to spend, I wasn't going to be able to purchase anything here. And in a time of potential plague, fire or no fire, I thought it wasn't wise to consume any food or drink, anyway.

"I'm just looking at your excellent baking," I replied.
"Anything take your fancy?" he asked.
"Everything actually, but ..." I paused, trying to come up with an excuse. *"My wife would be upset if I spoiled my appetite."*

Samuel ordered a couple of items and paid with the correct number of coins.

"I'm glad your friend doesn't come around here any more," the baker said.
"Oh really? Artur? Why is that?" Samuel asked.
"He would always buy ten items and pay with one pound and then insisted I give him the smallest number of coins possible in return. How's a man like me meant to find change for a pound all the time?"

Samuel chuckled nervously, took his purchases and led me out. He stopped outside to sit on a small bench and tuck into what looked like a meat pie. We sat in silence for a few moments until Samuel suddenly spoke.

"Obviously, the fire was a tragedy, but we must try to look at the positive in something negative."
"You're an optimist, Samuel."
"Yes. Just look over there. To the side of the theatre."

He gestured back towards where we had met. A stack of wood pieces were stored outside the theatre, all ready to be slotted in place where they were needed.

"We must rebuild, but in doing so, we can improve."

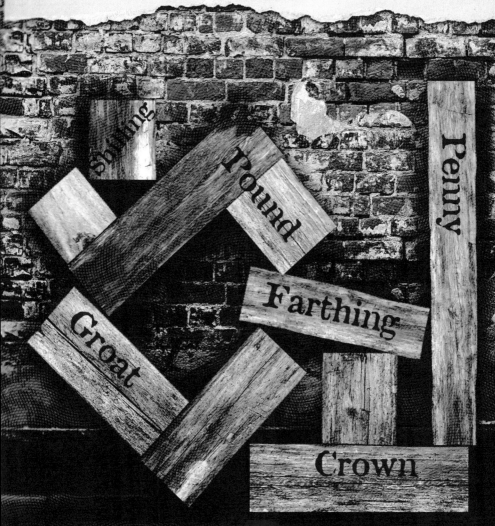

This struck a chord with me, as it's an attitude I share. I remembered my first car, and how devastated I was when it broke down and the mechanic told me that it wasn't worth fixing. It would have cost as much as the car was worth.

Of course, paying a fortune just to get the near-worthless car back on the road would have been frustrating, especially considering the poor wage I earned at my first job after university as an intern at the local paper. I realized that if I was going to have to spend money, I might as well upgrade. So I did. Now, if anything material broke in my life and couldn't be fixed, I just bought an upgrade so that it wouldn't feel like I was paying to have the same thing. It brought positivity to a negative situation.

Of course, upgrading London was something of a different proposition, I thought, looking around at all of the enterprise going on around me.

"I definitely agree with you," I said. *"It's refreshing to see that, despite coming from very different places, we are the same in many ways. Things have already improved here — we now have our trained bands ready to fight fires when necessary, and we must simply keep moving forward."*

Samuel stood up, having wolfed down his pie, and gestured for me to follow him back to the theatre. We walked in, and Nell was waiting for us.

"I wanted to give you something, Adam," she said as soon as we came in, and held out a piece of paper.

"Thank you," I said, surprised at her directness.

Looking down, I saw it was a page of a script, showing the monologue that she had been reciting earlier.

"If you ever see Artur again, please pass it on to him as a memento. He said to give it to the persone that came after him. This is the passage he helped me learn by reading it out to me."
"I will do that."

I looked down at the script. Something about it warranted closer examination, I thought, and I decided to read it through closely. I had to figure out what was up with this whole situation, and quickly, too. The trip to the bakery was enjoyable, but it had eaten up precious time.

As soon as I had figured out the word from the alphanumeric code that Artur left me,

I KNEW I COULD PROCEED.

FOR DIFFICULT HINTS TURN TO PAGE195
FOR MEDIUM HINTS TURN TO PAGE198
FOR EASY HINTS TURN TO PAGE........................ 203
FOR SOLUTIONS TURN TO PAGE........................ 213

All Mistaken, or the Mad Couple

Charles Hart

Amphe.
My Lord you had best Attend the Duke.
Because 'tis a Respect due to him.

Ortell.
I shall Madam at your Commands.

Exeunt

Amphe.

How has my tongue bely'd my too true
Heart, in speaking hate unto the Duke and love to Ortellus.
I hate the Duke, so Eyes do sleep that long have known
No rest, how cou'd my Lips give passage,
To such words and not have clos'd for ever.
Not by my hearts direction I am sure, for
That so swel'd being injur'd by my
Mouth, as had not Pride and reason Kept
It here from this unquiet seate, it wou'd
Have forc't away to Archimedes Breast,
And there have whisper'd to his heart my
Tongues untruth. Why shou'd I love this
Man, that shews me nothing but Contempt,
And hate: Rouze drooping heart, and think
Of that, think of it alwaies, so by degrees,
'Twill bring a Winter round thee, that in
Time shall Chill the heate of thy undone
And lost affections, oh 'tis not true that all our
Sex Love Change, then I might find one
Path that leades to it, that womanish vice,
Were vertue now in me, 'twou'd free my
Heart; and that were Charity.

Enter Duke.

See where he comes again, oh how I love
And hate that man. Now help me Pride and fil
My Breast with scorne, and prethee Tongue
Take heed you do not faulter, heare not
My heart that will distract thy speech, and
So betray my fain'd unkindness.

Duke.

What Amphelia all alone, weary of your new

Farthing, Penny, Groat, Shilling, Crown, Pound

"Howard?" I knew I had heard that name before. Samuel and Nell looked at me quizzically as I called out his name. There was no recognition from the earpiece though. Hmmm.

"The writer of the play?" Samuel suggested.

"Yes! And I saw his name on the poster!" I nearly shouted in excitement at the realization.

Walking over to the poster, I saw his name, twice, and sandwiched beautifully between the Howards was the word **"restore"**. A spark shot through my head from the earpiece. I had found my token.

"Restore?" I wondered aloud.

"Are you feeling all right?" Nell asked.

"I think so," I said, *"but I'm not entirely sure what Artur left for me."*

A beeping started in my ear. I guessed I was closer to my time limit than I had realized.

"I'm afraid I have to go, much like Artur," I said.

"It was lovely to meet you, Adam," Samuel said warmly. *"Perhaps we will see each other in future."*

"Or in the past," I joked.

"Quite," he replied doubtfully, in feigned understanding. *"And I hope you don't mind if I write in my diary about you?"*

It suddenly dawned on me whom I had been talking to this whole time. I tilted my head and looked down at the notebook that he had been clutching all along. It was marked with his name on the front: Samuel Pepys. I chuckled to myself.

"Perhaps it would be better if you don't make explicit reference to me, Samuel."

"Say no more. Should have been elsewhere and you don't want people to find out? Do not fear, it will be our little secret."

"Something like that. And goodbye, Nell; it's quite an honour to have met you, I must say."

Samuel Pepys

"Fan of the arts, are we?" she asked.
"Again, something like that. Stay out of trouble."
"Whatever would be the point in that?"

I felt like I should have tipped my hat at them. I felt like I should have been wearing a hat to tip at them. Having them witness my disappearance was not the wisest of moves, though, especially as one was a writer whose diary was published so widely, so I took my leave and walked outside the theatre. The beeping intensified, and my smile fell from my face as I realized that finding some privacy on this busy London street was going to be harder than I thought.

I looked over at the bakery. It was still filled with customers. The street was awash with people, and everywhere I could have ducked inside was not going to suit. Then I remembered the stacks of wooden beams that were just around the corner of the theatre. They might work to conceal myself behind. Running round the corner, I found myself face to face with the builder who had been above the stage when I'd first arrived. He was struggling to get the latest beam inside with another worker.

"Hey, can you give us a hand?" he called.

I nodded, half because I didn't want to cause a memorable scene and half because I hadn't got any clue what else to do. The beeping grew faster still as I assisted in pivoting the beam in. The men thanked me and wandered back outside to grab another. I darted through the doorway to find a dressing room, where an old man was trying on a costume. I apologized and raced to the next doorway. It led me back to the auditorium, which was gratifyingly empty. I breathed a sigh of relief. Now to focus on the word.

But what was it? The panic and stress had blanked my mind. The alphanumeric code had been a name. Harper? No, Howard. The writer of the play. And on the poster, it had appeared around the word ...

Restore.

My brain felt like it was erupting in energy, enhanced by the heartbeat pounding through my body. Focusing on the word, my token took me home.

CHAPTER FOUR:
RESTORATION

Michelle was waiting for me when I came to.

"*Have a fun little vacation?*" she joked.

"*Food was good, weather a bit poor though.*"

"*You didn't really eat anything, did you?*" she asked, recoiling.

"*No, of course not. But the honey cake did look tempting.*"

"*So what did you get this time?*"

"*Restore.*"

"*How amusing. You went to the Restoration period to get the word 'restore'? That's really the word that Saren gave you?*"

"*That's right. Although I guess he didn't actually give me the word. He led me towards finding the word. Maybe that's something he needs to do to avoid changing the past? Lead me towards it, so that it's me that finds it?*"

"*Perhaps. Either way, good work. Four down. Two to go. Would you mind heading straight to Dr Soutar?*"

"*It would be my pleasure. The gown is remarkably comfy.*"

I strolled off, keeping my distance from Michelle, and walked into the medical facility.

"*Did you miss me?*"

"*You seem remarkably cheery,*" Rhett said.

"*I am, yeah. I feel like we might succeed at all this.*"

"*You do?*"

"*I do. Because my token this time was 'restore'. And if I'm not mistaken, that could be a synonym for 'cure'.*" I smiled to myself as Rhett held out the now expected orange juice for me.

"*I think I'm okay, you know. If it's all right with you, I'd like to get some real sleep this time.*"

Rhett nodded, and after performing the required tests, he turned off the lights and left me to my rest. Unfortunately, with what was going on in my head, I barely slept a wink.

MEXICO

My first sight when I opened my eyes was the hazmat-suited figure of Dr Rhett Soutar.
"Did you sleep well?" he asked.
"Not at all."
Rhett chuckled.
"So you'll drink the sedative next time?"
"I think that would be wise."
"I've got a little gift for you. Something we've been working on – not exactly within my remit, but I do think it will help."

Rhett handed over a small earpiece, not unlike the one I was using to travel through time.

"Keep it in your other ear," he said. *"It should last longer than the other one – it doesn't drain as much power."*

I followed his instructions and was immediately overwhelmed by a reverberation of sound inside my head that felt like it was scraping my eardrum. I winced before it mellowed out into a more comfortable and quiet hum. At that pitch it was almost reassuring, like a fan whirring on a hot night.

"What does it do?" I asked, instantly aware of the quiet echo of my own words repeated back to me, a fraction of a second after I spoke. It was unsettling.
"Can't you tell?" he replied, before abruptly walking out of the room.

I blinked. This far into my travels I'd grown accustomed to Rhett. In fact, I had almost learned to let his voice, muffled by the hazmat suit, soothe me. But in that exchange his demeanour was different. He had been more forceful, almost insistent, and I decided to trust in his new gift – perhaps more than I should, considering it came from a guy who constantly used a hazmat suit around me.

I followed him out and turned towards Michelle, who was standing in the next section of the gallery. There were clear Mexican influences in the artwork, and Michelle was looking at a painting of a woman with flowers at the crown of her head.

"Frida Kahlo," she announced, having heard

my footsteps. *"Not one of hers, of course. Just from an admirer."*

I nodded and looked around. I was getting used to this, and tried to focus on the task ahead of me.

"There's something I need to tell you," Michelle said, her voice a little tight.
A sense of dread washed over me.
"Has something happened?"
Michelle held up a tablet and tapped the screen to bring up a video.

"In world news, the previously unknown infection spreading through Europe has been identified as bacterial in nature. This new strain of Neisseria, responsible for diseases such as meningitis and gonorrhoea, is now seeded around the globe, with cases in over 150 countries. It is believed to have originated in the United Kingdom."

"Hang on. Neisseria?" I blurted out.
"Precisely. Our calamity is here," Michelle solemnly announced.
The severity of what was happening had never been clearer. A hypothetical problem that we were trying to get ahead of, or understand at all, had suddenly become all too real.

"How did this happen?"
"We don't know. Mutations and natural evolution happen all the time. However, new diseases with the perfect combination of factors to be able to spread effectively are rare: they must be not so deadly that they don't have time to be passed on to other hosts, yet must be infectious enough to spread before we've even spotted it's a problem. It appears this may be one of those."
"I'd better get to work."

Michelle nodded and passed the fully-charged first earpiece to me.

Looking around the gallery, my eyes were drawn immediately to a black-and-white piece depicting skeletons dancing. There were eight of them, each holding different items.

"It's meant to be purgatory," Michelle volunteered. *"The dead are holding items related to their job when they were alive."*

I nodded. I couldn't decide if it was morbid or not. I appreciated that different cultures approached the concept of death in different ways, but this seemed a bit too celebratory for me. I looked for a little too long, but then pulled myself away; I had a job to do.

I next noted a small jade pendant with a gold finish that was displayed on a soft black velvet stand. It had a variety of colourful dangling elements hanging from it. It was beautiful, and most likely worth more than I could afford, so I kept my hands off it.

A small pot sat beside the pendant. It was decorated with images of warriors on the top half – it reminded me in a strange way of the Greek pottery. However, the bottom half seemed suspicious to my now-trained eye. It had skulls on it, like the skeletons I had seen before; perhaps this was linked? There was also a series of numbers, and *la fecha* was written on it.

Michelle stepped in. *"It means 'the date' in Spanish,"* she told me.
"So this may have something to do with how to figure out when I'm heading to?"
"I assume so. And, just so you know, dates in Spanish are the same as ours in the UK. Day first, then month, then year," she continued, helpfully.

I nodded in gratitude, and moved on.

The final artefact that I took notice of was contained in a glass box and hung on the next wall. It seemed to be part of a mural; it was old and worn, but with enough detail left to make its artistic value clear. Arrows of various colours above the central images caught my eye. I suspected there was some information hidden within, but what?

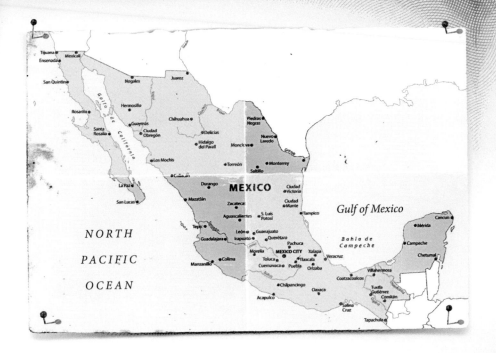

On the wall there was also a modern map of Mexico, with a number of cities marked with their English names.

"It looks like I'm heading to a city in Mexico?"
"I didn't know you spoke Spanish," she said, looking surprised. She seemed to be making a joke ... I didn't quite get it. *"But yes, that seems pretty certain."*
"And I need the date too, I assume?"
"Yes – this time we believe that we need the year, month and day. Hopefully, that will be enough, unless we've greatly miscalculated."

As soon as I had a location and a date to visit,
I KNEW I COULD PROCEED.

14 April 1953, Mexico City.

I closed my eyes, ready for the pain. Nothing came. I opened my eyes and looked back at the painting. Maybe I needed to focus more. I closed my eyes, thinking of the date and the place. Nothing.

"You'll get more out of the art if you're actually looking at it." A female voice I didn't recognize spoke from behind me.

I opened my eyes to see the painting again. I hadn't moved. Or had I? I suddenly became aware of more people milling around me. The painting I had seen in the Wexell gallery was indeed still in front of me, but both it and I were in another gallery. Was I in Mexico City? I turned around to see where the voice was coming from. It was the woman from the painting, lying in a large four-poster bed in the centre of the exhibition. Frida Kahlo, in the flesh, was in front of me, surrounded by swathes of flowers and some of her own work. It was almost like she was herself displayed as part of a larger piece of art that took over the entire gallery.

"Frida Kahlo?" I asked.
"What gave me away?" she smiled.
"Aren't you surprised that I know who you are?" I asked.
"You have come to see my exhibition, in my home city, filled with paintings that I have created, many of which have my own visage in them. If you didn't know who I was, I would be surprised."

I should be getting better at this time travelling by now, but it appeared I was still saying stupid things. Fortunately, while previously I had to hide part of myself — and my knowledge of whom the historical figures around me were — this situation gave me licence to be a lot freer about what I knew.

"Well, I'm a fan."
"Please excuse me for being unable to personally show you around the Gallery of Contemporary Arts," she replied, waving her hand around the building.

I looked up at where she was gesturing to see a sign labelled above the doorway. A tall gentleman was standing by the entrance. He spotted me talking to the artist, took a second to look me over – was he judging me? – and then briskly approached with a quick smile.

"Please excuse me, Ms Kahlo; allow me to look after our guest," he interrupted.
"Thank you," she said as she lay back, seemingly exhausted.
"Why don't you follow me? I can show you around. I'm Vittu."
"Adam," I replied, turning around to say goodbye to Frida as we took our leave.
"I must apologize, I didn't see you come in. Otherwise, I would have given you a little more information about the exhibition," Vittu said.

He seemed to laugh as he said that. Why was he taking such an interest in me over the dozens of other visitors around us? Did he know who I was? Did he have knowledge of my task, or even my travelling through time? Had he met Saren previously? A multitude of questions flashed through my mind and I decided to take a chance.

PRAN 4

135

TOOL 5

"I don't suppose you know someone called Saren, do you?"
Vittu smiled. I took that to be a good sign.

"I should probably show you some of Ms Kahlo's exhibition,"
he replied, deftly deflecting my question. But that was enough
for me to know to pay special attention to everything he said.
*"Everything about this exhibition has been planned and
designed by Ms Kahlo. Sadly, she has been sick for most of
her life – polio as a child, then a bus accident at 18. As a
result, tragically, she has never been able to have children.
Instead, you see many monkeys in her paintings. I believe she
considers them to be her children."*

SLIT 6

Perhaps Frida Kahlo's presence in her bed was not one of design or fanciful artistic whimsy after all, but simply one necessitated by sickness. It was another example of ill health and disease following me through the centuries. All the same, I was not sure Vittu should be sharing such personal information with me — unless there was a reason for it.

Suddenly, I realized he was leading me past a couple of small paintings of trees that were part of the exhibition. I smirked as I realized what they were. It was perhaps a little on the nose: monkey puzzle trees.

BRAN 7

TRUL 5

SHUL 6

I felt the pressure of Vittu's hand on my arm. It was time to move on. I'd been staring at the monkey puzzle... puzzle... for too long. I followed him around the exhibits, passing murals, portraits and other fantastically colourful artworks. I wanted to stop to examine them, as much for their aesthetic beauty as the possibility of spotting some hidden information, but he was insistent that we continued.

Finally, we stopped in front of four flowers, displayed with unusual names written underneath them. Although, the more I thought about it, the less sure I was that these were the names of the flowers -- they felt more like a collection of letters that related to them, somehow. Vittu spoke, interrupting my thoughts.

"As much as I would like to ask you what it is you would like to know, perhaps it will be more helpful if I simply lead you on to what I believe might align with your interests?"
"I assume you have been forewarned of my interests?"
"Let's just call it an educated guess."

With all of this veiled and coded talk, I still couldn't be completely sure how much Vittu knew about my situation. Saren had previously always attempted to minimize the changes he had made in the past, giving people only just enough knowledge to pass on that would help me, but that would not make sense to anyone else. Vittu, though, was acting as if he knew more about me and my purpose than I did myself.

Vittu beckoned me over to where he was standing, just out of view of Frida. I sensed that he was familiar with this sort of game — if that was the right word — as if he was used to showing people just what they needed to see.

"Here is something I've painted," he announced. *"These others are all Frida's work, but I insisted on having one of mine here, and I am quite clearly a hard man to turn down."*

BLES 4

I looked at the work. Vittu's painting wasn't an entirely different style from Frida's. The little I knew about her work was reflected in this painting of the windows of her iconic blue house. I had seen pictures of this house before, but there was something unusual about the windows, something that seemed off to me. Symbols had been added to the sides, and on to the panes themselves.

Before I could investigate further, I had the prickling sensation of being closely watched. I glanced over and saw Vittu examining me closely, while smiling with what looked like pride. I was almost afraid of discussing the symbols with him, in case he took offence that I was looking for some hidden meaning rather than appreciating the painting for what it was. Then I realized he was proud of how much attention I had been paying to the windows — he knew that I had found the clues he had left.

"Was this ...?" I started.
"Shhh," he warned, looking around. I could see that he was concerned about bringing attention to it, or anyone else seeing us. His furtiveness made me wonder if Frida was even aware that his painting was here.

"Lots of monkeys everywhere, aren't there?" I said instead, changing the subject.
"Absolutely. Frida is a great lover of them."
"So I hear."
"The monkeys and the flowers," Vittu continued.

I was struck by a thought, and walked to a spot where I could see Frida again. I saw one unusual flower that I had not noticed before, tucked into her hair, and mentally noted its characteristics.

I was feeling confident after everything I had gone through, and so I gestured towards Frida's flower.
"That's clearly the important flower, right?"

Vittu's demeanour immediately changed. He became very serious, and gestured to me curtly.

"We can't talk here. Follow me outside."

I did so, and was stunned into fits of blinking and squinting by the contrast in light from the shadows within the gallery to the piercing sunlight of the street.

"Do you know who influences her?" Vittu asked, indicating the wall behind us.

I looked back and saw a poster for her exhibition with a familiar symbol on it. It was the Wexell "W".

"I suppose the same organization that influences me," I admitted.

Vittu's face was not exactly what you would call shocked at that revelation. He must have been the one in contact with Saren, and Saren must have told him a lot more than he had told the others about who — and what — I was.

"So, do you know a man named Saren, then?"

"Yes. But this isn't about him. This is about Frida."

I nodded, and Vittu continued.

"She doesn't have long left. The man you know as Saren knows more than he should about what will happen."

"Is he here?"

"Yes."

Instinctively, I looked around, as if I would spot someone wearing sunglasses and a trench coat, looking at me suspiciously over a newspaper.

"Frida's legacy will live on beyond her, but outside Mexico she is still treated as a tourist commodity." Vittu gestured to a stand on the roadside selling the kinds of items that wouldn't be out of place in my time at the worst tourist hot spots.

"That cheap tat is meant to allow rich foreigners to bring back a part of Mexican culture. Junk, really. Frida's art has become overly commercialized and ended up lumped in with that mass market rubbish. Do you think someone's happiness is dependent on what they achieve in their life, or in the potential of what they have done?"

"I think if you're happy with your actions, then it doesn't really matter whether you see the fruits of your labour or not."

"I am glad you think that," Vittu muttered. That wasn't reassuring. Just how much did he know about me — and *my* future?! *"So, these items. Just how relevant do you think they are to Mexico, or even Frida's life?"*

"I think they are about as relevant as the Aztec symbols on the poster for the exhibition — they're a way of selling something to people too ignorant to know better."

"Exactly. Selling something to someone influences what they do. Sometimes it is for good, and sometimes for bad. But are you bad if you do something bad by accident, without realizing the final outcome?" he mused.

The conversation had taken a very philosophical turn, one that I didn't fully understand. What was worse, after that sentence it was like a wall had come down. Vittu would not answer any of my questions, no matter how much I pleaded. He just stood there enigmatically, staring at the stall filled with souvenirs.

I could tell that Vittu was implying something, but without him providing more context it just seemed like a leading question, one that was trying to coax me into saying something I may later look back on with regret. Was he – or someone else – trying to manipulate me into doing something I shouldn't do? Something with "bad" outcomes? The Trojan horse came swimming back to me. I had too many questions, and not enough answers.

A beep from my earpiece reminded me that it was time to focus on the task at hand. My role had always been to find my token and return home with it. Given that my own existence was under threat if I failed, I decided to concentrate solely on that for the moment and worry about Vittu and all the rest when I had more time.

Then again, the thought crossed my mind that I could use this chance differently. Unlike in my other travels, I was so close to my own time period that I could live here without too many difficulties. What if I just resigned myself to staying here, 40 years before I was born, to learn from the past and potentially use my knowledge of the future to avoid some of the cataclysms that I now knew were approaching?

No. Looking at Vittu, I could tell that was the wrong path. He knew more than he was letting on – more than me, I was sure – and he was trying to guide me back. I had to trust him and Saren, as I had done before. What's more, I knew this future but I didn't know *my* future, or how the world might end. I had to trust that what I was doing was the right thing and leading to "good" outcomes.

Somehow, this interconnected series of puzzles should unlock a word that would be all I needed to focus on to get back home. I considered everything I had seen in order to try to find an alphanumeric code that made sense to me.

Once I had determined how everything related to each other and had found my token,

I KNEW I COULD PROCEED.

FOR DIFFICULT HINTS TURN TO PAGE196
FOR MEDIUM HINTS TURN TO PAGE199
FOR EASY HINTS TURN TO PAGE............ 204
FOR SOLUTIONS TURN TO PAGE............ 215

'Flores'... flowers. The word caused a zap in my head and I knew I had found the token. Were flowers our solution – our salvation – somehow? I looked over at Vittu, who nodded at me. He turned and walked away as I felt the electric power roll like spikes across the rest of my body. He'd had a purpose, and by helping me find the token, he had succeeded.

Then, just as my eyes closed, it hit me why I'd had a strange feeling about him: the familiarity, the philosophy, the knowing questions ...

I opened my eyes, the usual pain subsiding, and couldn't help but shout out my revelation.
"It was Saren!"
"Welcome back, Adam," Michelle said cautiously. *"Saren was the token?"*
"No ... he was there ... in 1953. He was waiting for me, to guide me to the token."
"Which was?" she pressed.

I paused for a second. This deception over his identity had unnerved me, and suddenly I lost my trust in everything. Michelle's laser-like single-mindedness was immediately focused on the word I had gone through so much to find, and it made me feel like my life was secondary to my mission. Perhaps it was.

"Flores ... flowers," I mumbled.

I knew, of course, that my mission *was* probably more important than my life. This calamity that was happening as we spoke was impacting on a global scale. Of course my life was worth less, and so it made sense that Michelle was eager to know what our escape from the disaster might be.

"Flowers?" she asked, confused.
"That doesn't help us, does it?"
"It's not clear to me yet. We have a calamity, a specific microbe, which is currently infecting us, and perhaps a cure that is delivered as a "Trojan horse" – maybe hidden inside something – and through a flower?"
"Could the flower be what's hidden inside the Trojan horse?"
"Perhaps. But what flower?"

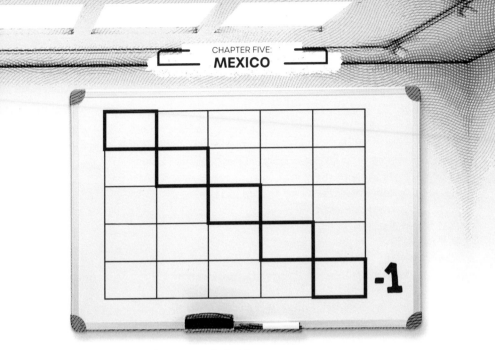

"I guess we've got one more place to go to find out."

"Not quite yet," said Dr Rhett Soutar, standing in the doorway to the medical area in his familiar hazmat suit.

I remembered thinking about the extreme cautiousness he had shown after each trip, far beyond even Michelle's own unwillingness to come close to me. Now it all seemed so justified — he had been right all along. Since this whole adventure had begun, the "calamity" had started for real. While it surely couldn't have been my doing that caused it, I couldn't help but feel responsible — I was on the inside of this mission. And shouldn't Wexell have informed the public or the government, or someone, that there was danger right from the start when they knew about it?

Arguably, telling anyone that we'd travelled through time to find the word "calamity" in ancient Egypt would likely not have been believed by anyone in authority. And I guessed that even if they did, they would have been just as nonplussed as we were.

Following his beckoning hazmat-clad arm, I left the gallery and entered Rhett's office as usual, spotting the orange juice on the table. I immediately picked it up and started drinking it, remembering the awful night's sleep I had had before my last adventure.

"I don't suppose it's too late to say that I prefer apple juice, is it?" His face was hidden behind the suit, but I could tell that he was amused from the little bob his head made. Looking around the room, I saw a 5x5 grid on the whiteboard on the wall that had not been there before.

While the board had contained numerous medical notes, nothing had previously stood out like this. It made me look closer; this was a habit that I had picked up over the course of my travels. The top left square had a thicker outline, and the pattern continued down diagonally. A large "-1" was written to the right of it.

"*So, just one more section of the gallery to explore, then?*" Rhett asked, interrupting my thoughts. I unwillingly dragged my attention away from the grid.

"*That's right. Should I give you this second earpiece back now?*"

"*Hold on to it; you may still need it.*"

"*Need it? What exactly does it do?*"

"*Well, I wasn't aware that you spoke Spanish.*"

"*I don't. I haven't.*"

He laughed. "*Something tells me that without that earpiece, Mexico might have been a lot harder.*"

Ah, of course. It made sense, in a way — the quiet echo in speech that I heard. The earpiece somehow translated everything I said, not just what I was hearing, but the very words I was speaking. This was almost as formidable a piece of tech as the time-travelling device.

"*Do you know where you're going next?*" Rhett asked.

I shook my head. I hadn't wanted to think about it before now, but my curiosity had inevitably meant that I had looked ahead at my future sections. Some things had been immediately recognizable, like the sarcophagus or Frida Kahlo. The last section, however, was something I couldn't pinpoint. I hadn't been able to make it out completely, but its central display seemed to be a blue orb of some kind, glowing above the LEDs situated beneath it. I couldn't help but be a little excited to see where I was headed, and nervous that it all would come down to this final section.

"*I met him, you know.*"

"*Who?*"

"*Saren. The traveller before me.*"

"*Any more ideas as to why he's left you this breadcrumb trail?*"

"*I think he's trying to help me stop a calamity, but I'm concerned that it's too late.*"

"*You think what's on the news is related?*"

"*Possibly. And I keep coming back to Wexell throwing all their eggs into one basket. I'm really worried. If I fail once, it's not just me that's lost in time, but maybe the only chance to stop this disease.*"

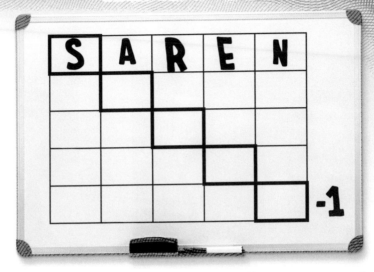

Rhett walked over and touched me kindly on the arm. I half expected him to use it as an excuse for a blood test, but it didn't happen.

"I think you're doing great," he said, and continued after a pause. *"This adventure may be yours, from your perspective, but I've very much appreciated being a part of it."*

He paused again, looking at me intensely. Then he nodded and went over to the whiteboard, wrote *"Saren"* in the top row of the grid, and looked up at it. Without another word, he walked out of the room, leaving me quite baffled and slightly on edge, even though the orange juice was already having an effect.

Suddenly, a prickly wave swept across my back. Something wasn't right. I had overlooked something. I looked up at the whiteboard, my brain struggling to make sense of it with my diminished mental capacity from the juice. I had to focus. What did it mean? I somehow knew this was hugely important, and I couldn't allow myself to pass out. Focus, Adam. I kept blinking to try to straighten my mind.

And when I realized what the whiteboard meant,

I KNEW I COULD PROCEED.

FOR DIFFICULT HINTS TURN TO PAGE..............196
FOR MEDIUM HINTS TURN TO PAGE.................199
FOR EASY HINTS TURN TO PAGE.....................204
FOR SOLUTIONS TURN TO PAGE......................217

Rhett. Dr Soutar. The names that the traveller had taken … if I took the first letter from his first name, then the second from the second and so on, then moved the letters one back in the alphabet, it spelled *"Rhett"*.

My mind raced – as fast as it could under the influence of the drugs. Why would he have hidden his identity from me? Was the hazmat suit simply his way of keeping his identity secret? He had used the medical safety excuse, knowing that he would meet me in Mexico, face to face.

Dr Rhett Soutar was the traveller from the future. Dr Rhett Soutar was Saren. He had been leaving me clues, tokens; words – all leading towards a Trojan horse that had possibly caused a calamity! Was he evil all along? A bad man, causing bad outcomes? Had he somehow unleashed this disease on an unsuspecting world, and used me to ... why had he used me at all?

I had to get to Michelle to explain what I had learned. I scrambled out of bed, but I was already too far gone.

I collapsed on the floor of the medical ward.

CHAPTER 6

THE FUTURE

Rhett. The traveller.

I was desperately trying to focus on what I needed to remember when I was shaken awake by Michelle.

"Adam, are you all right?"
"Sure ..." I said. *"I'm used to the juice. But Rhett ..."*
She interrupted me. *"He's gone. Casually walked out of the building without a word, still in his suit. I came in here, saw the grid and put it together. He was Saren! We are out looking for him now but ..."*
She shrugged.
"How come we never knew? Unless ... did you know?"
"No."
"Did you see him without his suit on?"
"Of course. Before you were here, there was no need for it. But I had no idea who he was. I think he was hiding his identity from you in the knowledge that you would meet him face to face in Mexico. That was why he was so careful about the suit; he had to guide you in Mexico to ensure you completed your task successfully, without you knowing it was him."
"But the infection. The calamity. Was he the Trojan horse? Did he come back in time to cause it?"
"If he did, why would he go to such lengths to provide the artefacts? That doesn't make sense."
"So, have we failed now?"
"I don't believe that we have. Not yet. Your work isn't over, Adam."
"The last section of the gallery!"

Michelle nodded. Without wasting any more time, I jumped to my feet and we rushed back to the main area. The final exhibition was dark and ultramodern-looking. Just then, I realized Rhett's tech was still nestled in my ear, and the betrayal I felt about his manipulation made me want to hurl it across the room. I restrained myself.

"He gave me this. Do I still need it?"
"What is it?" Michelle asked.
"You don't know?"

What had I been using? Was this a bug of some kind for Rhett to spy on me? I guessed not, since he had been present during the only trip that I had used it for. Still, I definitely didn't want to use it any longer. I handed it to Michelle who reluctantly took it from me, as my anger over Rhett's deception bubbled over.

"How did this happen?" I exploded. *"I trusted you all. This operation is so secretive and yet somehow he managed to infiltrate you?"*

"I'm sorry, Adam. He was hired directly by my husband. I never questioned it."
"So why was he here? Why couldn't he just accomplish what he wanted without us?"
"I fear that the only way to discover that is to finish your journey," Michelle said, gesturing to the two earpieces that were now sitting alongside the blue orb I had spotted beforehand.

I studied them for a while, before putting the recharged time-travel technology in my ear as normal. I picked up the other earpiece that Rhett had given me to examine it more closely, and as I did I noticed the orb begin to glow brighter when I moved it closer.

The blue light emanating from the orb didn't seem to be from hidden LEDs or any other obvious source. Instead, it was like the object itself was its own source of light. I bent to look more closely, and saw a pattern of symbols etched into its side. Straightening up, I looked down on it from directly above to see that other symbols formed a circular pattern around the top of it.

I blinked and looked away, the afterglow of the light imprinted on my vision. I decided that to save my eyes, and so that I could examine both sets of symbols at the same time in case that was necessary, I should trace the symbols that were located on the top of the orb. Satisfied, I turned away to next observe a painting of a futuristic city skyline, unlike anything we currently had on Earth.

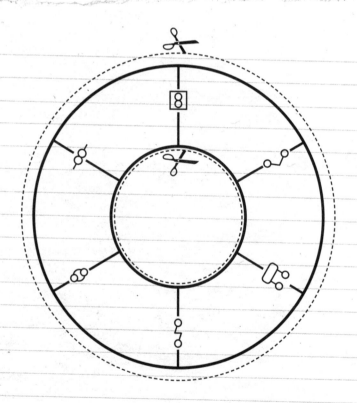

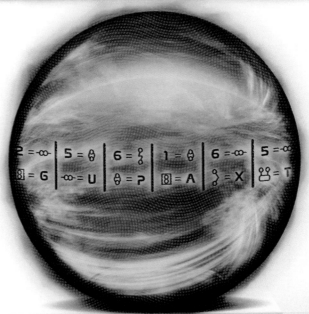

"How would you like to see the future?" Michelle volunteered.

"It's always been a dream of mine."

"Is that so?"

"I'm sure everyone feels that way to some extent, but I've always felt like we're so restricted by the age that we're born into. My grandfather, for example, died before the internet existed, and I've often wondered how he would react to it if he could see it as it is now, mere decades later. Would he marvel at the idea that all of human knowledge is available to almost anyone in the world, nearly instantly? Living through this technological change is amazing. Surely everyone must be curious about what unthought of inventions change the world next."

"I remember my teachers telling me that I needed to learn long multiplication because, and I quote, 'It's not like you'll be walking around with a calculator in your pocket.' Such a small thing, but even that was revolutionary," Michelle agreed, nodding.

I thought about that for a moment and then continued.

"But I suppose, with that, it was never just about knowing how to come up with all of those calculations, was it? I imagine they still have to teach it all in school, despite technology seemingly rendering skills obsolete."

"Of course they do. Because no matter how perfect and advanced the technology, we still need these skills for one main reason: user error."

"That makes sense." I considered it. *"You need to know what you're expecting the answer to be, so that you either trust what the tech comes up with, or you realize you pushed the wrong button."*

"Blindly trusting in technology is something we have to learn to avoid," said Michelle.

NEWTOPIA

Perhaps if we'd had this conversation earlier, I wouldn't have been so willing to use Rhett's earpiece without knowing what it was. Plus, it was hard to imagine an AI that could think so nimbly that it could solve the puzzles I had in order to get this far. Those teachers were on to something after all.

I focused my thoughts back on to the task at hand, and my possible trip into the future. Why would Rhett need me to go there? Why couldn't he simply tell me the information I needed, especially if this future was the time that he had come from?

Looking down I spotted the name of the painting: *Newtopia*. It sounded like a fictional place, but then wouldn't everything to someone who had never heard of it before? Something else was etched underneath the name, and I had the feeling it was too precise to be an accident.

I looked over at Michelle again to see if she had anything to say about it, but she just smiled and shrugged at me. We were both out of our depth here.

4

3
0
5

2
1

"How did you get these?" I asked.
"The Traveller. Saren. Rhett." She
corrected herself.
*"But how? How did he bring
things from his time?"*
*"I suppose you've just never
tried bringing things back."*
"I've never thought about it."
*"One assumes that if you're
in contact with something
that is movable then it
will be contained within
whatever field the earpiece
creates. Otherwise, you would
have lost the other earpiece,
your clothes, or anything in
your pockets."*

I was suddenly aware of all
the wasted opportunities. But,
of course …

*"And that includes disease.
Microbes on my clothing."*
*"Which is why we took such care
to quarantine you each time."*

I fell silent as I thought about
the illness sweeping the planet
as we spoke. It might not have
come from me, but I was
certainly wrapped up in the
cause of it. Focusing on the
items in the gallery was my
priority, not only to take my
mind off what I might have
unwittingly been part of, but

also to complete my task, to see if I could end it. I saw what looked like a patterned fabric of some sort hanging on one of the walls.

"Is this a curtain?" I asked.

"It's more likely to be a piece of clothing. A scarf, perhaps?" Michelle said.

"Why is a scarf hanging here?"

She shrugged. *"If it was 1,000 years old, you wouldn't be surprised that it was in the ancient Egyptian section, would you?"*

"But that's different."

"Is it?" Michelle chuckled.

"But what's to stop this having been mass-produced and sold in every shopping mall across the country?"

"It could have been. But actually, the material this is made of is unlike anything you'd find here. It's water-repellent, incredibly hard to stain or damage, thin and lightweight, but still very warm. Oh – and it blocks light extremely effectively."

"Are you sure this isn't just a blackout curtain?"

"My point is, this might be normal to someone, or some time, but to us it is unique and rather special. So why shouldn't it be hanging here?"

"Today's trash is tomorrow's treasure?"

"Something like that. But, in this case, in the reverse. Tomorrow's trash is today's treasure. Take this item, for example. It's essentially a battery-powered light."

I looked around, expecting to see another glowing crystal, but was disappointed to see nothing of the sort. Instead, I followed Michelle's gaze to what looked like a fairly standard hanging light fixture. It was so ordinary that I hadn't even thought that it was part of the exhibit at first.

"Don't tell me. It's technology far in advance of our own."

"In a sense. It uses LEDs, much like our own tech, but the real advancement is in the batteries. They are sealed within the item. There's no wire — that might as well just be string attaching it to the ceiling."

"So it's rechargeable?"

"Possibly," Michelle replied, raising her eyebrows. *"But we don't know how. Maybe using some kind of wireless charging — a technology we already have."*

"So what's the advancement?"

"It's been on since we created this gallery and hasn't needed to be charged once. The capacity of this battery is unfathomable."

"Impressive. I suppose one small improvement in a single facet allows further progress. In this case, a higher battery capacity allows for more functionality, the same way mobile phones grew to have full-colour screens and internet access once we created the capacity to power them."

"Exactly. And the control is connected by some wireless tech we can't understand either."

She gestured to the wall, and I spotted a nondescript metallic dial. A dimmer switch seemed so 1970s. Why was this light here, and why would this be a piece of technology that Saren brought with him? Surely the future had a lot more to offer than this.

"There's one final object we don't even understand the function of," she said. *"Perhaps it is just art? No matter what we do with it, we can't seem to unlock its secret."*

She gestured over to a large grey metallic wheel. It looked technological, but with a use that meant nothing to me. For all I knew, it could have been the inner workings of a washing machine, or an artist's creation meant purely for aesthetic purposes.

Using the items I had just seen in this gallery, I knew I needed to determine a year and location in the future that I would be able to travel to. Maybe it was simply this "Newtopia" place, but I thought that was too obvious. What if the solution was the name of somewhere I had no knowledge of? I just had to trust that my experience so far would let me know for sure when I had found the right word, even if it didn't immediately make me think of a location.

So, a four-digit year and a word that I hoped was familiar to me. Once I had both of them,

I KNEW I COULD PROCEED.

FOR DIFFICULT HINTS TURN TO PAGE196
FOR MEDIUM HINTS TURN TO PAGE199
FOR EASY HINTS TURN TO PAGE205
FOR SOLUTIONS TURN TO PAGE218

I.S.V. Wexell

2410, Wexell.

The familiar flash took over my body, bringing me somewhere unknown. I had no firm expectations, and no ideas at all about what "Wexell" might mean there. I caught a last glimpse of Michelle looking over at me with trepidation. She nodded, and I was gone.

Ahead of me a white wall filled my vision, with the word "Wexell" written on it, embossed in what seemed like a shiny plastic material, and with light glowing from the outlines of the letters. Before it was written: "I.S.V."

A calming female voice echoed around me. ***"Welcome to the International Space Vessel Wexell."***

Whatever I was unconsciously expecting, I certainly wasn't expecting that. I spun around to see a huge window behind me. As if detecting that I was looking through it and out, the lights in the room quickly dimmed, revealing a star field stretching out as far as I could see. Worryingly, the view was spinning. I felt as if I was stationary, but clearly the vessel was careering swiftly through space.

"Please prepare for emergency landing," the voice warned.

I rushed forward just in time to see a big blue planet coming into view. My first thought was that it was Earth, but it didn't look like any view of our home that I had seen before. I started to panic, my breathing a little too shallow for my liking. I'd had a panic attack before, long ago, but I assumed I'd overcome them. Now, realizing I was thousands — no, probably millions — of miles, and several centuries, away from home, my friends and family. I understood the reaction I was having. It was hardly a normal situation to be in. I gave in to it for a few seconds, sinking to the floor and letting it engulf me.

No! I had to try to suppress the dread I felt and focus on the important task at hand. Who knew what relied on me? I closed my eyes, breathed as deeply as I could three times, opened my eyes again and forced myself to move around the room to investigate what was at my disposal.

The lighting was mostly provided by several blue orbs like the one I'd seen in the centre of the gallery I had just left. The room itself was larger than I would have expected for a space vessel; I had always thought that space ironically would be at a premium in outer space, given the energy required to launch anything out of orbit and off into the stars.

However, in the middle of the room was a flat octagonal table that seemed to have a panel at the centre. I figured this might be a display. I touched it, hoping that it would activate, but nothing happened. I felt out of my depth and confused in a way that someone from even 50 years ago might be baffled by a modern touchscreen smartphone.

Fortunately, I knew what I could fall back on: my best sci-fi knowledge inspired me to speak to whatever technology ran the ship.

"Computer? Computer activate," I tried.

Nothing. That was the last time I trusted a B movie for life tips. I had to move on, especially if I was due to crash-land soon. Perhaps there was a procedure I should follow? Could I even attempt to complete my mission and get out of there before we crashed?

I darted to one of the walls that wasn't covered in glowing text or a window to find a clean desk with a tiny plant on it. This was much more 21st century. Above the desk was a shelf stocked with books, some of which I recognized as being about important parts of history, and others I did not.

Next to the shelf was a chart by the door that looked like a map of the ship I was standing on. Different rooms were identified by different colours. A white light was softly pulsing in the centre of one marked "H-Lab". I assumed that was where I was, and, looking more closely, the "you are here" confirmed my suspicions.

Adam, go to the Medical Bay.

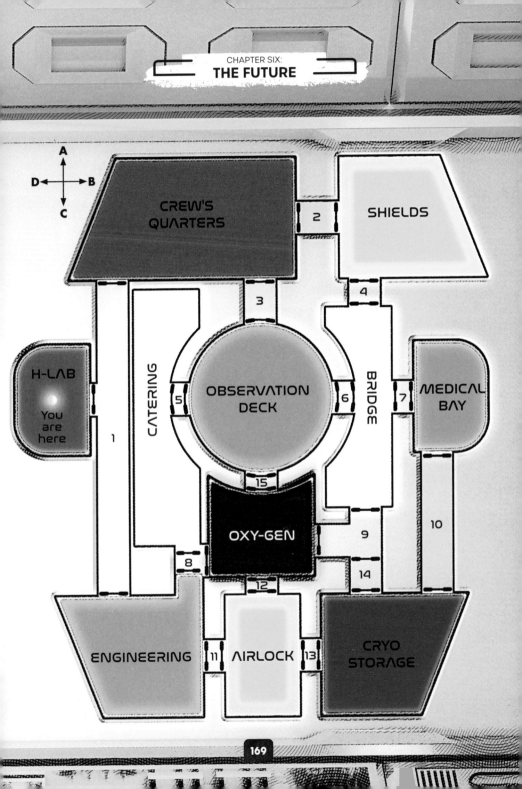

Now I was starting to worry a little, unsure of what to do next. Everything was so far removed from my normal experience, I didn't know what was important and what wasn't. But surely the central control table had to be something.

Looking at it from a different angle, I noticed a small inscription on one corner. It was a line drawing of a sideways face, with lines coming out of the mouth. Perhaps this was an indication to speak, and the ship was voice-activated after all. I just needed to know the correct activation word. Alongside the face were eight lines, placed at the same level as the bottom of the image, like they were underscoring where characters should go.

I felt that this still wasn't enough to tell me what to do. One last sweep confirmed that the room was remarkably empty other than a black clipboard hanging on the wall on the other side of the "I.S.V. Wexell" sign. It was just a maintenance log, but it listed a worrying number of issues with the ship.

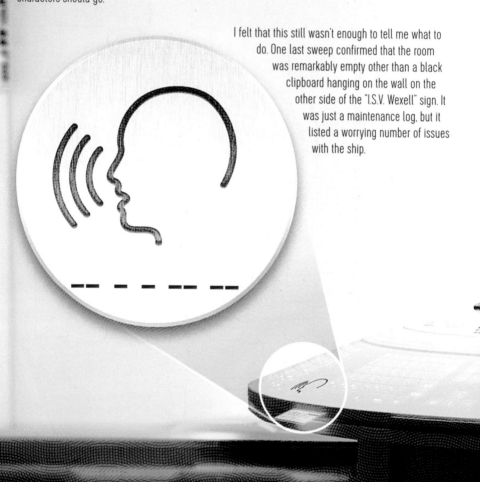

MAINTENANCE LOG

Due to ongoing maintenance, corridors 4 and 6 are closed.

Doors malfunctioning in Oxy-Gen. Do not use B or D side doors.

To contain ventilation, only use door D in Medical Bay.

Engineering is completely out of bounds due to dangerous flux particles.

I walked over to the single doorway leading from the room, in case there was any more to explore. However, it wouldn't open, either just motion-activated from my presence as every sci-fi movie ever made indicated it would be, or from any brute physical force I could apply. I was locked in here and must have to activate the central table somehow to get out. And ideally that would be *before* the crash landing!

Surely it couldn't be that hard to figure out, given that this was all I had access to. I was sure I just had to speak a word to activate the ship's computer.

Once I knew this word – a very familiar word –

I KNEW I COULD PROCEED.

FOR DIFFICULT HINTS TURN TO PAGE196
FOR MEDIUM HINTS TURN TO PAGE199
FOR EASY HINTS TURN TO PAGE205
FOR SOLUTIONS TURN TO PAGE220

"Rhett?"

Almost instantly, the table sprang to life. A grid of lights on it illuminated the rest of the room, and slowly but surely a holographic human came into view, drawn pixel by pixel from the feet to the face. It spun as it did so, calibrating itself to my presence, until it was finally complete: a giant projection of the man who had deceived me for so long.

"And you must be Adam," he — or it — guessed.

"Rhett," I blankly stated, unimpressed enough with the man to override my excitement at the light show in front of me. *"Or Vittu, or Saren. What is your real name?"*

"Ah, you know who I am. That will make this easier. Or at least who I am a replica of."

"So you're not really him?"

"No. Of course not. I'm a virtual holographic image of Dr Rhett Soutar, created by the ship's computer."

"I thought maybe you were, I don't know, talking to me over a video call or something?"

"No, and I can tell by your demeanour that you really don't like me," it correctly surmised.

"You deceived me."

"Not me, Adam. Not me. And I can only apologize for whatever the real Rhett did to you. Just be assured that he did it for a good purpose."

"He lied to me. Pretended to be someone from my time in order to gain my trust and manipulate me."

"You have been on travels too, yes? Are you saying you haven't done the same thing to others when you have gone back in time?"

I thought for a moment. Was what I had done the same thing? No. I was trying to stop the calamity. But what if he was, too. I had been hiding myself from people who couldn't comprehend what was happening. Did Rhett think the same of me? Had I been too harsh on him?

"I was following his instructions not to change anything. Not to alter the past."

"And he was doing the same. Your present was his past. But now you're here and this gives us a rather unique situation," the hologram said, seeming to pause for effect. For a virtual image, it seemed to like showmanship.

CHAPTER SIX:
THE FUTURE

"*Which is?*" I blurted out impatiently.

"*Adam, don't you see? None of us can change the past, because it could cause a paradox that could change the reasons for you to originally change the past. It's the classic timeline problem. Think of it this way: If you witnessed the death of your beloved pet as a child, and upon becoming an adult you went back in time to save its life, the child version of you wouldn't have lost his pet, and therefore when he became an adult, he would not go back to save its life. Are you seeing the problem here?*"

"*Of course. So the pet would die after all, which would make me go back in time in an endless loop.*"

"*Two loops, actually. Two timelines.*" The hologram noticed I was getting frustratedly confused; it was almost too real to be a computer program. "*But none of that really matters. All that matters is that you're here.*"

"*So why am I here?*" I pressed.

"*You can't directly influence the past in order to change the future. Nor can Rhett. But there is no reason why you couldn't influence the future in order to change the past. That's why you're here.*"

It was starting to lose me completely. The hologram could see as much.

"*Think of it this way. The calamity. That's why you're here.* **Calamity**, **Neisseria**, **Trojan horse**, **Restore**, **Flowers** *and something from now.*"

"*The calamity? You started the calamity in my time. You infected the world!*"

"*No. Not with the calamity. Something lesser. Consider it a trial run. A preparation for humanity to try to teach you all how to handle what was coming.*"

"*I don't understand. Is it not real?*"

"*I'm afraid it is real, Adam, but not real yet. Neisseria martagonis. It infected us quickly. Stealthily. It was halfway across Earth before we even identified it. Much like pandemics of the past, and your present. The version in your time developed by itself. It is the ancestor of our disease. It is almost harmless right now, even if highly infectious, but it will become something far, far deadlier in a few centuries. That's why we chose your time specifically to try to ... leave the package, shall we say?*"

"So, it's not a threat back where I come from?"

"Correct," the hologram said. "The timing of the pandemic in your time was merely meant to motivate you."

"Well, here I am. What do I do? Surely I can't prevent your pandemic, otherwise it would cause one of those endless loops."

"Exactly. Now you're getting it. The Wexell Initiative developed the unique time-travel device you have used – the earpiece."

"Weren't there two?"

"The other is simply a universal translator. It helped you to speak Spanish in Mexico, and the Cyphstress was also given one. There was no time to teach anyone to assist you back then."

It was starting to fall into place, but I still didn't understand how I could actually help, if I couldn't stop the calamity. The hologram interrupted my train of thought.

"The governments of the world came to Wexell, begging us to use our technology to go back in time to save the past somehow, even to warn people of the upcoming disaster. Wexell refused."

"They knew they couldn't stop it by changing anything."

"Billions had died across the globe, but Wexell couldn't save them. Then a plan was formed. One last-ditch attempt to save what was left. Dr Rhett Soutar would head out on a scientific research vessel to attempt to locate something that could stop the Neisseria. All of our antibiotics had long been useless against the superbugs that were already a problem in your time."

"How long was he searching?"

"Not him. Me. He and the crew were safe in suspended animation on the ship while I looked for a planet with signs of life, or anything that could be a potential candidate."

"Is he here now?"

Suddenly, a dark red light enveloped the room, with an alarm that shook my body like I was standing next to a speaker at a music festival.

"No, he has already left on his time travels. And we are about to crash-land into that planet."

"What's the plan? What did they come up with? I don't understand!" I desperately shouted over the alarm, which now added a high-pitched screech to the din of the alarm.

My ear was flatlining. I awoke to the sudden realization that I was out of time, and the earpiece's volume quietened down to nothing. I was stuck here. I wrestled to my feet and was showered with sparks from an electrical system that must have been keeping the doors closed in the corridor.

The door suddenly blasted open and the change in pressure shook the spacecraft. I noticed that my balance was off centre. We had landed on the blue planet I'd seen from afar earlier and were embedded somewhere, at an angle. I was clearly incredibly lucky to be alive, for all sorts of reasons. It's not every day you survive crashing onto an alien planet.

Staggering towards the medical bay, I saw that the power cut had removed all illumination except the light coming from the blue glowing orbs. It was enough to see my way inside the bay, towards a box attached to the middle of a table, which had a glowing word on the outside: "Adam". I opened the box's latch and found what looked like a tablet inside, secured there so that I would know where to find it in the case of a crash landing, I presumed.

It turned on in my hand to a simple written message.

I instinctively swiped across to find a page of information headed with the words "Martagon Turksap". It was a flower, or rather an antibiotic that could be derived from this flower. If I could find it, somewhere outside, perhaps it could save us all in the future and my present, if it was needed. I took the tablet and walked towards where the airlock was meant to be. Part of me was nervous about having to open it up. I knew that the tablet had told me it was OK, but it wasn't every day you find yourself on an alien planet without a spacesuit. Or with a suit for that matter. I was unsure whether I would suffocate, or even be poisoned by something in the atmosphere, but my trepidation was short-lived. I saw a huge hole in the ship left by the impact, and a rock jutting through the metal. If I was alive now, I would probably be OK out there.

Adam, thanks for coming. Head outside. The planet has a breathable atmosphere. It's the only place we're likely to find the cure. This information should help you.

"There is no time. You must secure yourself in the medical bay to reduce the risk of harm occurring to you on impact. Go, now."

The door to the room slid open and I instinctively ran. My memory of the route through the ship held and I darted through, not even slightly tempted to contemplate the wonders of human engineering I was racing by as I was trying to get to my destination, half-guided by the blue orbs lining my route.

As I sped along, I suddenly recognized the sound that was piercing my ears above the ship's alarm. It was my earpiece. Time was running out, and I had no idea what I still had left to do, or even if I would survive the crash. The battery was about to expire, and without charge I would not make it home, or fulfil whatever this plan was. Then a sudden jolt threw me to the side of the corridor outside of the medical bay, and I lost consciousness.

I took a deep breath and stepped outside. It was sand, like a desert. I walked around the outside of the ship for a while, alone, somewhere outside our solar system, at a time when, according to the hologram, the rest of humanity may well have been wiped out. The solitude was almost calming, and certainly awe-inspiring. It all felt a bit pointless without a way home, the inevitability of our species' extinction finally removing the everyday stresses from my life. If I were to die here, I would never have to worry about missing a train, politely laughing at unfunny jokes, or washing up dishes again. So that was something.

Still, while I was here, I might as well try to find this antibiotic. But there was only desert as far as the eye could see. I looked back at the ship, and spotted the rock that had pierced the airlock.

Underneath the rock was a small opening, a hidden cave. The hologram had clearly still had some control over the ship and had crash-landed exactly on top of where I needed to be. I lowered myself into the opening and walked down the steep route to a huge cave below, which was lit by what I assumed were bioluminescent plants. Vines hung down from the roof, and mushroom-like plants grew from the cave floor, gaining nutrients from some unknown source — perhaps an underground stream, or whatever life managed to spring to existence on this planet.

I looked back at my tablet. It scanned the cave without my help, and displayed what I imagined were biological representations of any living thing around, alongside the DNA strand of the plant I was looking for. A green light suggested it was in here. I was close, but which plant was it? The culmination of my mission was in this cave. I had to identify the antibiotic organism, and doing so would give me a five-letter word, one that I would recognize from my previous adventures.

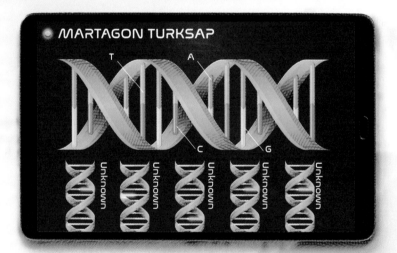

Once I had that,
I KNEW I COULD PROCEED.

FOR DIFFICULT HINTS TURN TO PAGE196
FOR MEDIUM HINTS TURN TO PAGE199
FOR EASY HINTS TURN TO PAGE...................... 205
FOR SOLUTIONS TURN TO PAGE.......................... 221

CHAPTER SIX:
THE FUTURE

Vittu! That's how I knew that I had the right plant. Rhett had encoded the DNA sequence with one of his pseudonyms. I had it, and the vines would produce Martagon Turksap. With a spring in my step, I returned to the ship.

For some reason I was half expecting a celebration with all of my friends — as if they could have been hiding around the ship as part of the most elaborate set-up of all time. But of course, there was nothing. And unless I could think of a way to get home and travel back in time, there would be nothing for the rest of my life.

I wandered around my new home, trying desperately to think of something. My elation at finding the cure was ebbing away fast. The power was still off, and I walked through the entire route back to the H-Lab without seeing anything that could help me. I could barely fix my car back home; I didn't rate my chances of figuring out the intricate mechanics of this ship anytime soon.

As I entered the room, Holo-Rhett sprang to life. It must have saved the last of its power for this very moment.

"H-Lab stands for Holo Lab, right?" I suggested, pleased with myself for figuring out one final thing.
"Adam, I'm so proud of you," it announced. It must have been programmed to say that, but it still felt good, though.
"But what does it matter? The earpiece is dead."
"Oh Adam, you've come all this way, and you've failed at something so simple? This isn't the first time the earpiece has run out of battery, is it?"

Of course. When I had figured out the simple way I could get home,

I KNEW I COULD PROCEED.

FOR DIFFICULT HINTS TURN TO PAGE196
FOR MEDIUM HINTS TURN TO PAGE199
FOR EASY HINTS TURN TO PAGE.....................205
FOR SOLUTIONS TURN TO PAGE........................222

I finally realized how stupid I had been to worry about the battery in the future. Sure, if I was stuck in ancient Egypt with no way to re-energize the tiny time machine, I would be in trouble, but Michelle was able to recharge it on every visit. It was obvious that there would be the facility to do it here, in the technology's own time period, and I had already seen the way to do it first hand. I removed the earpiece and gingerly brought it over to one of the blue orbs, praying that it also had the wireless charging ability I had seen before. It instantly began glowing with a deeper blue.

I was so thankful to Holo-Rhett. How long would I have sat here without thinking of that myself?

"How long will I need to charge it for?"
"Just a minute or two," Holo-Rhett replied.

I had seen a lot on my travels, but for some reason this stood out as something truly revolutionary. All of the technology of the future — like the time travel, the hologram, the spaceship — it all seemed so far away from where we were as a society. But this tiny piece of progress, a wireless fast-charging technology, was so relevant and so accessible to my time that for me it was the bigger marvel.

"So, what do I do now?" I asked. *"What is the plan, if I can't change the past?"*
"You must take the flower home. Isolate it, and keep it safe for when it is needed."
"But, I don't understand," I pleaded.
The earpiece beeped once more, an indication that it was ready.
"In your future, it will be there when the plan is made."
"What? That doesn't make any sense. What about the token I found? Vittu?"
"It is to be expected that you are mixed up. My own power reser—" Rhett began, then flashed into a collapsing cascade of pixels.

He was gone. I couldn't risk summoning him up again. The ship's power could drain the orbs, and this could be my last chance to get home. I plugged the earpiece in, clutched the plant and thought of the word. My new token: Vittu. What a strange final choice. Why this name? Why not simply Rhett again? Vittu.

And, in a final painful flash, I was home.

Michelle was there, as she had been when I left, and she immediately looked down at the plant.

"Is that …?"
"*It's what this whole thing has been about,*" I confirmed.
"*I will get it analyzed,*" she said with relief, reaching for it.
"*No, wait. We can't change the future,*" I instinctively blurted out, Rhett's initial message on the wall in Egypt ringing through my mind.

Michelle paused, clearly unsure whether or not to override my decision for the good of her objective — and possibly humanity.

"This …" It was finally starting to make sense to me. "*All of this has to happen the way it originally happened, otherwise Rhett would have never come back in time, you would have never recruited me, and I wouldn't be holding this vine.*"
"*Then what has this all been for?*"

I started pacing in order to get my brain thinking, and Michelle followed. With everything that had happened to me recently, I felt I had to keep moving to deal with the adrenalin coursing through my body. Slowly, I ventured a few words, those that the hologram had told me. "A plan was formed."

Michelle tilted her head up, waiting for wherever I was going. Then it hit me.

"*Michelle, this whole thing. It's a reaction to this future calamity. When I went to Egypt, the messages left by Saren – Rhett – they were left in a way that they could only be given to me, at this very specific point in time, without changing the past or the future of those involved. And they were left at a time and place when the majority of people who could have been affected by his actions would be wiped out very soon after by the outbreak that was happening at the time. This doesn't mean he didn't make any changes, it just means that anything he did would not have the chance to make a change that would create a timeline loop. Now that we have this flower, we need to engineer a situation where we do the same thing, but for the future.*"

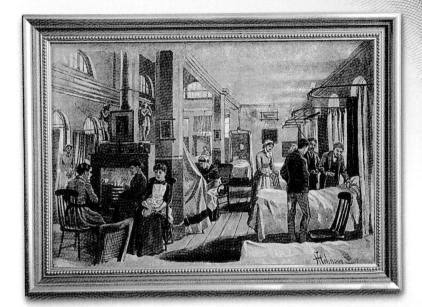

"But how can we? What about the calamity?"
"The calamity must happen. And the governments of the future must believe that they have no other option but to send Rhett away as a time traveller. We must hide this flower until after the point when they make the decision to set all of this in motion."

Michelle looked at me with confusion. I couldn't blame her. It had taken me a while to get to this place of understanding.

"Half of the planet will be wiped out. That still has to happen, which ... is an absolute tragedy. But we could conceivably save the other half by preserving the means to do so, and keeping it secret until that point. That way, we don't change the future until after Rhett has left, and there's no timeline loop."
"I'm sorry," she began. *"but you're suggesting we have the cure to this disease, and we don't get it ready for the outbreak that kills at least half of ALL humanity?"*
"We must follow the plan. Everything must happen exactly how Rhett knows that it did, otherwise it would change his actions, and this timeline could never happen. As far as he was concerned, he was leaving behind a doomed human race unless he could find a cure."

My mind was spinning, putting the pieces together to find a solution to a problem that had already been solved.

"The plan that was formed by Rhett in space was to put into motion plans to find the solution they need, but hide it from themselves until after the plan was formed."

That was a lot of planning! I had been far too harsh on Rhett, as he was clearly an incredible and meticulous man. The second that Rhett had left Earth in his attempt to find the cure, Wexell — custodians of the cure for centuries — must have known it was then safe to finally reveal it. They couldn't have done so before they had sent Rhett off, because otherwise the finding of the cure would never have happened.

They were sitting on the solution all along, watching as billions died but were unable to use it until Rhett had figured out how to make me find it and hide it. It was unfathomable.

Michelle looked at me, the cogs turning in her head to determine what she should do.

"So, where do we hide it? The flower."
"My last token — the hologram ..." I trailed off, realizing that Michelle would have no idea what I had just experienced. *"I found a hologram of Rhett. He told me it was expected that I was 'mixed up'. Hang on ..."*

Once I had determined how I was mixed up, and what my final token meant, I would know where to hide the flower so that it would be safe until it was needed all those years in the future.

Only then,
I KNEW I COULD PROCEED.

Vittu was a "mixed up" anagram of "lvtut". That's where I had to hide the plant.

"You're going to put it in the sarcophagus?" Michelle questioned.
"Why do you think Rhett brought you artefacts for a museum-slash-art gallery?"
"Preservation. Of course. It's a place where we go to great lengths to preserve items, and not tamper with them."
"What better place than here to stash something you want to keep secret for generations?"

I walked over to the ancient Egyptian section, my heart pounding with excitement and success. Michelle was already holding what looked like a storage tube; Wexell had clearly been prepared for this sort of eventuality. She twisted the tube, unlocked it and pulled it apart. I placed the vine delicately inside and she sealed it within; centuries would pass before anyone would see the fruits of all of our labour.

"So, should I just ...?" I looked at the sarcophagus, gesturing that I should open it up. It seemed odd to unseal something that had been entombed for millennia.

BREAKING NEWS

THE DISEASE HAS YET TO CLAIM A VICTIM.

Michelle nodded, and I gently tried to open the lid. It turned out to be extremely heavy, but with her help, we opened a gap wide enough to place the tube inside.

"You know, I thought all this would end up with something more exciting than placing a flower in a sarcophagus." I was only semi-joking. After crash-landing on an alien planet, I was quite pleased at the ease of completion of this final piece of the puzzle.

We sealed it up and stood back. It was strange, knowing that we would never get to confirm that what we had done would be a success.

A jingle brought Michelle's attention to her phone. It was a breaking news story.

"The disease has yet to claim a victim."

"At least, our version of it hasn't," I said. *"This is just the start. I guess Rhett was right."*

We stood in silence for what seemed like a long time. Having potentially saved humanity, it only seemed right to pause for a moment. The colossal achievement of what we had accomplished weighed on us. I had visited times and places that I could have never imagined. I had met people that had had a huge effect on society, culture and humanity. Maybe, through my actions, I had become one of those people. Rhett certainly was, and I hoped, wherever and whenever he was now, he knew that. For now it was time to guard the mysteries of this sarcophagus for centuries — just one more secret for Wexell to watch over.

Eventually, I broke the silence.

"For some reason, I really fancy an orange juice."

HINTS AND SOLUTIONS

DIFFICULT HINTS

PROLOGUE
It was **bold** of Wexell to hide the solution in plain sight.

EGYPTIAN GALLERY
THE YEAR
The King is dead. Long live the King!

THE LOCATION
The cat is quite iconic.

EGYPTIAN PUZZLES
THE SEQUENCE
You should reflect on where to start.

THE OBELISKS
Try to see the full picture.

THE TAPESTRY
Start small and then mix and match.

THE HIEROGLYPHS
Get in shape with the hidden patterns.

THE NUMBER PYRAMID
The bottom row is the final piece of the puzzle.

THE FINAL NAME
Alphanumeric is the key. Do you have anything that could be easily translated from numbers?

VICTORIAN GALLERY
THE YEAR
The plate points the way.

THE STREET
You're running out of time to find the full street name.

VICTORIAN PUZZLES
VICTORIAN POLICEMAN
If you can work out the date and time, then you can ascertain who he is.

THE SEQUENCE
Out of the shadows comes light.

SHADOWS
They wouldn't be much use in a game of Jenga, but they are very useful to you!

HEARTBEATS
The numbers of shadows help us identify parts of the patients' heartbeats.

SLIDING BEDS
The patient in bed number 11 needs to be removed.

GREEK GALLERY
THE YEAR
Asterisk the Greek forms the Order of the Helmets.

THE LOCATION
The plate will be handy to help figure out where you are going

GREEK PUZZLES
THE SEQUENCE
I don't want to point out the obvious, but ...

THE DANCERS
Strictly Come Pointing.

THE FOOD
Each group of dancers only likes one type of food.

THE MAP
Navigate the Aegean Sea in all four directions.

THE MAZE
X marks the start.

THE FINAL LOCATION
You have seen this place name a few times before.

RESTORATION GALLERY
THE YEAR
The eyes have it!

THE LOCATION
All the world's a stage. Even the paintings.

RESTORATION PUZZLES
THE SEQUENCE
Start with the end. And the start.

BAKERY ITEMS
If bakery products be the food of love, read on.

COST & CHANGE
There's always a lot of change at the bakery.

NUMBER ORDER
The last shall be first and the first last.

WOODEN BEAMS
"Lattice" hope you can solve this part of the puzzle.

THE FINAL NAME
This is an A1 clue.

MEXICAN GALLERY
THE DATE
At least the first Adam had only one missing.

THE LOCATION
All that glisters is not gold – it could also be red and black.

MEXICAN PUZZLES
THE SEQUENCE
Start with Frida's children.

MONKEY PUZZLE + WINDOW
The monkey puzzles over the grid references.

TOURIST STAND
Show me your wares.

FLOWERS
The colours and shapes of the flowers need some logical deduction.

WHITEBOARD
Five become one, or does one become one?

THE FUTURE GALLERY
THE DATE
The line in skyline should lead to the answer.

THE LOCATION
Wheels within wheels.

THE FUTURE PUZZLES
THE SEQUENCE
First, find the correct route through the ship.

SPACESHIP
Take a colourful trip around the spaceship.

BOOKS
Not colour by numbers, quite the opposite.

SPEAKING ICON
The speaking icon can give us a breakdown.

CAVE
Solving puzzles is in our DNA.

THE BATTERY PUZZLE
This one really isn't that hard if you've been paying attention.

THE FINAL NAME
It looks like Mummy's got a bit mixed up.

MEDIUM HINTS

PROLOGUE
The four animals on the mural all appear elsewhere.

EGYPTIAN GALLERY
THE YEAR
Finding the date is as easy as 1-2-3, but not necessarily in that order.

THE LOCATION
X marks the spot on the map.

EGYPTIAN PUZZLES
THE SEQUENCE
The future traveller has provided some help.

THE OBELISKS
I think it's time for some reflection.

THE TAPESTRY
So the last shall be second and the first shall stay first.

THE HIEROGLYPHS
Is there a way of converting just those four hieroglyphs into Arabian numbers, I wonder?

THE NUMBER PYRAMID
If you spot the tally marks on the bottom row, you're nearly there.

THE FINAL NAME
She has been very helpful.

VICTORIAN GALLERY
THE YEAR
The London-based paintings are the key and there are two possible combinations of them that could give a year in the reign of Queen Victoria – but which one is it?

THE STREET
'Let's all go down the Strand!' (To a parallel street just off the Strand anyway.)

VICTORIAN PUZZLES
VICTORIAN POLICEMAN
The noticeboard has everything you need for the date, but you should look elsewhere as well.

THE SEQUENCE
The next puzzle is a mere heartbeat away.

SHADOWS
Concentrate on the four wooden blocks and find the missing pieces.

HEARTBEATS
Some bold shapes in the seven columns of the heartbeat chart combine to make letters, numbers and possibly other characters – but can you work out which ones you need to use?

SLIDING BEDS
There are three parts to this solution: (1) the bed number sequence; (2) the solution to the Heartbeats puzzle; (3) alphanumeric conversion.

GREEK GALLERY
THE YEAR
The symbols on those helmets appear elsewhere. What was that Michelle was saying about numbers? It might have all been Greek to you at first, but perhaps you should take some time to work it out.

THE LOCATION
The frieze will also give you a helping hand to solve this – five hands in fact.

GREEK PUZZLES
THE SEQUENCE
The formations of the dancers look familiar.

THE DANCERS
Follow the direction of the dancers' pointing in each group to get five sequences.

THE FOOD
Let each group of dancers point you in the direction of their favourite food and drink, and then you can make a list of all the different places they come from.

THE MAP
Can you use the order of the locations discovered from the food stalls to discover a new sequence of directions? This will give you the final keys to solving the puzzle.

THE MAZE
X is not a variable here, but it will help you to start finding the numbers.

THE FINAL LOCATION
Alphanumeric is the way forward.

RESTORATION GALLERY
THE YEAR
Let the cat's eyes (and ears) guide you in various directions, before joining the dots on the tapestry.

THE LOCATION
The grids on the note will get you off to a good start. Do they match grids that you can find elsewhere?

RESTORATION PUZZLES
THE SEQUENCE
Everything should change after you uncover the bakery order.

BAKERY ITEMS
Reading scripts really makes me hungry.

COST & CHANGE
A pound is a lot to pay for ten items, but at least you get lots of different coins back.

NUMBER ORDER
Be careful when reversing.

WOODEN BEAMS
Building rafters is a little bit like Tetris at times.

THE FINAL NAME
I would like six letters, but not from the postman.

MEXICAN GALLERY

THE DATE
The missing ribs will need some jug juggling to find the date.

THE LOCATION
The number three and the colours red, gold and black are the key.

MEXICAN PUZZLES

THE SEQUENCE
Use the symbolic trees to identify the correct tat.

MONKEY PUZZLE + WINDOW
Reflections of trees can be seen in the coloured window.

TOURIST STAND
Time for a stocktake.

FLOWERS
The colours and shapes of the flowers in the vases will help with the key flower, and this will give you something extra to arrive at the final solution.

WHITEBOARD
Five mysterious names give us the diagonal key.

THE FUTURE GALLERY

THE DATE
Line up the buildings in order to get to the answer.

THE LOCATION
Try wheel alignment on three wheels, but you will need to do it six times.

THE FUTURE PUZZLES

THE SEQUENCE
The books appear to be out of order.

SPACESHIP
Eight rooms will lead to eight different colours.

BOOKS
The colour sequence will bring some order to the dates of the books.

SPEAKING ICON
Splitting up will put you on the right lines.

CAVE
Follow the glowing clues, but it isn't grapes that we are interested in.

THE BATTERY PUZZLE
There's a reason you could never re-charge the battery in the past.

THE FINAL NAME
Mummy's name is all the clue we need.

EASY HINTS

PROLOGUE

The letter contains each of the animals in the mural and the word *count* is italicised. Why?

EGYPTIAN GALLERY
THE YEAR

Follow the sacred scarab to the sarcophagus and the four tally numbers will give you the number you need.

THE LOCATION

You get a capital view from here.

EGYPTIAN PUZZLES
THE SEQUENCE

The way forward has been drawn for you.

THE OBELISKS

See the obelisk image (right) – what do you see?

THE TAPESTRY

You spy a cruciform before avian and coleopteran creatures and that gives you the correct order.

THE HIEROGLYPHS

Ignore all the hieroglyphs apart from the Eye, Cross, Bird and Beetle – then look at the number shapes formed by each of those groups.

THE NUMBER PYRAMID

Complete the number pyramid replacing the tally marks with the hieroglyph numbers previously found.

THE FINAL NAME

Convert the numbers on the bottom row of the pyramid to letters using an alphanumeric code.

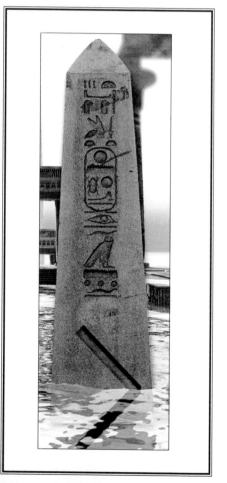

VICTORIAN GALLERY
THE YEAR
Follow the number sequence on the plate and you can't go wrong.

THE STREET
The clock times are as follows: 5:19 – 6:20 – 1:20 – 2:01 – 3:22 – 7:15 – 9:11 – 4:09 – 8:03. Can any of that be converted to letters, perhaps using the alphanumeric sequence A = 1, B = 2, etc.? On the map, not every street name is given in its complete form. For example, in the southeast quadrant of the map "Buckingh S" is the abbreviation of Buckingham Street. The answer you seek is similarly abbreviated (and the answer will not include the descriptor Street, Lane, Road, etc.). However, a visitor from Devon would have no difficulty in working this one out.

VICTORIAN PUZZLES
VICTORIAN POLICEMAN
The items on and behind the desk will provide the final information you need to solve this conundrum.

THE SEQUENCE
Everything leads to pushing that bed out of the door.

SHADOWS
Cut out the "shadow shapes" and use the four "wooden blocks" to provide four codes of numbers and one letter.

HEARTBEATS
Take the four alphanumeric answers from the Shadows puzzle and look at which numbers appear next to which letters. For example the number 1 appears with the letters A, B and D. Then look at the bold shapes in column 1 of the heartbeat chart next to the names beginning with A, B and D. Can you make anything with those three shapes?

SLIDING BEDS
The beds need to be moved around in order to get the bed numbered 11 out of the door, and that number sequence found by noting the numeric value of the beds in the order that you move them will lead to the word that you need. However, some of the numbers are over 26 – they are too large to be converted to letters. Is there anything you've learned from a previous puzzle that could remedy this?

GREEK GALLERY
THE YEAR

The first nine Greek letters on the plate starting with A represent 1–9. The next nine letters starting with I represent 10–90. The final nine letters starting with P represent 100–900. Finally, if a letter is preceded by a comma, think thousands. Convert to Greek numbers and match the colours of the helmets on the urn design before solving the calculation.

THE LOCATION

Working left to right, match the hands on the frieze with the hands on the plate, then find the Greek letters. Only five are needed. Reflect on that.

GREEK PUZZLES
THE SEQUENCE

Finish by using not one, but two maps to find the correct numerical sequence.

THE DANCERS

Look at each of the five groups of dancers and uncover their directional sequences by finishing with the set of dancers with their hands on their hips.

THE FOOD

Match the groups of dancers with the stalls of food that are set out in the same way. By following the same directional sequence previously found for each group of dancers, this will lead you to a second sequence of place names for each food and drink group. For this you will also need to convert the Greek letters to the English alphabet, using the letters shown on the plate on page 81 as a guide. The alphabet is not an exact match to the modern-

day alphabet, but in this case, the alphabet can be assumed to translate as:

A, B, Γ, Δ, E, F, Z, H, Θ, I, K, Λ, M, N, Ξ, O, Π, Ϙ, P, Σ, T, Y, Φ, X, Ψ, Ω, ϡ

A, B, C, D, E. F, G, H, nothing, I, K, L, M, N, nothing, O, P, Q, R, S, T, U, V, X, Y, Z, nothing.

THE MAP

Using the previous sequences of place names found within each food group, you are now looking for a third sequence. In order to find this you need to find all the place names on the map of the Aegean Sea and note down the direction in which you need to travel between them. This will give you a set of sequences to use in the final part of the puzzle.

THE MAZE

Follow the directions given in each of the five directional sequences and you will get five numbers.

THE FINAL LOCATION

Convert the numbers using alphanumeric conversion and that will give you the place name.

RESTORATION GALLERY
THE YEAR
Sort the eyes on the tapestry into groups depending on which direction they are looking in and then join the dots, but only for the directions indicated by the cat. Can you see any numbers? But what order should they be placed in?

THE LOCATION
Match up all three clues to the paintings to find the three words. The first grid can be found on the painting directly above it, and the final grid matches the cabinet. But how can you use elements of the paintings to translate them to letters?

RESTORATION PUZZLES
THE SEQUENCE
You can finish up by placing the missing beams in the rafters.

BAKERY ITEMS
Compare the scripts and all will be revealed.

COST & CHANGE
Calculate the cost of the items Artur used to order, the change required in farthings, then work out the least number of coins given in change to make that up.

NUMBER ORDER
You now have a sequence of numbers, but not yet the correct order. Getting back on script will help in this instance.

WOODEN BEAMS
Match the beams to the missing pieces of the rafters to make up the wooden lattice frame, and then do the calculations.

THE FINAL NAME
Alphanumeric conversion is the key.

MEXICAN GALLERY
THE DATE

Two number sequences combined will unlock the date – one from the missing ribs and the second from the jug. Can you use the information from one to decode the order of the other? The missing ribs will always equal the number of remaining ribs on the other side of the skeleton, or on the other side of an arm. Where there is a hole in a skeleton's side with no mirroring ribs for a reference, you can assume there is one rib missing.

THE LOCATION

Match the red, gold and black colours on the mural to the colours on the pendant to lead you to the location. There are 26 dangling elements on the pendant. Perhaps each dangling element represents one individual part of a commonly used 26-part whole?

MEXICAN PUZZLES
THE SEQUENCE

Once the tourist stand has given you a sequence, add the floral command to it.

MONKEY PUZZLE + WINDOW

The trees reflect the grid references to guide us to the correct coloured window symbols, all in the order shown by the poster from top to bottom.

TOURIST STAND

Take note of how many items are for sale in and around the stand and order them as per the windows.

FLOWERS

Each element of the alphanumeric codes beneath the seven flower vases represents a visual attribute of the flowers, from petal shape to colour and beyond. Apply the same key to the important flower and this will lead to a mathematical calculation that will help solve a second alphanumeric puzzle.

WHITEBOARD

Using the names of the mysterious traveller will nearly get you there. Then you need to follow the final whiteboard instruction.

THE FUTURE GALLERY
THE DATE
Follow the scrawled images and you'll be on the right lines to find your way to Newtopia.

THE LOCATION
Using the six clues shown on the orb in order, align the three wheels to give you the name of a familiar place.

THE FUTURE PUZZLES
THE SEQUENCE
Where can the eight digits provided by the books be placed to create an alphanumeric sequence?

SPACESHIP
Take the only route possible to the Medical Bay and observe the eight different colours as you go.

BOOKS
The dateline we are looking for needs the colour sequence to get the books in order.

SPEAKING ICON
Eight lines give us eight numbers but only five letters.

CAVE
Using the colourful DNA, if you join the glowing bars to the vines, with a bit of floral number-crunching you should get a very familiar name.

THE BATTERY PUZZLE
In the future, wires aren't needed for this sort of thing.

THE FINAL NAME
The name might be Egyptian but starts with the number four in Rome.

SOLUTIONS

PROLOGUE

The four animals in the mural – cat, spider, bear and chicken – all appear in bold in the letter from Wexell, in that order. The letter also includes the word "count" italicised, to alert you to its importance. In order to find the code, therefore, you must count the number of animals in the mural. There is one cat, two spiders, three bears and four chickens, giving the very creative code: 1 – 2 – 3 – 4.

EGYPTIAN GALLERY
THE YEAR

The six segments of the scarab beetle on page 23 represent the six segments on the sarcophagus on page 20 that are painted with white tally marks. The dot on the beetle marks the starting point and the arrows reflect the sequence in which they should be read. This reveals the Roman numerals I – III – II – III which equates to the number 1323, so the date is 1323 BCE.

THE LOCATION

Look at the icons shown on the cat on page 23 and find them on the map on page 22. Then draw lines between the two pairs of icons and where the two lines cross is the location: Cairo.

EGYPTIAN PUZZLES
THE SEQUENCE

The wall markings below Saren's message show the sequence of puzzles: OBELISKS – TAPESTRY – HIEROGLYPHS – TALLY MARKS – PYRAMID.

THE OBELISKS

If the obelisks on page 32 are "reflected" in the water, the half symbol above water becomes a full symbol, as shown below: < 0 >].

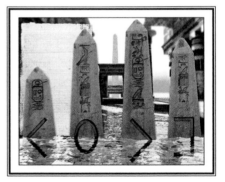

THE TAPESTRY

The tapestry on page 34 indicates you should put the obelisks into ascending height order, so the sequence will start with the first one, being the smallest, followed by the last one, followed by the second and third – a new order therefore of 1 – 4 – 2 – 3. If you apply that reordering to the symbols found in the obelisks puzzle, that sequence becomes <] 0 >. The tapestry shows a hieroglyph below each of those symbols and that gives you the pattern: Eye – Cross – Bird – Beetle.

THE HIEROGLYPHS

If you look at just those four hieroglyphs (Eye, Cross, Bird, Beetle) within the grid on page 29, you will see that each of them form some sort of pattern, and those patterns are each in the shape of a number (see hieroglyphs grid image below). For example, looking at the beetles in isolation, they form the number 19. The four shapes in order give the following numbers:

Eye = 5
Cross = 8
Bird = 8
Beetle = 19

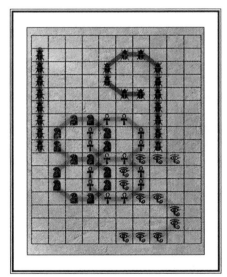

THE NUMBER PYRAMID

If you put those four numbers into the pyramid on page 31, in the four blocks marked I, II, III, and IIII, you can now fill in the rest of the pyramid. The number above two blocks is always the sum of the numbers in those two blocks (see pyramid image below for the full solution).

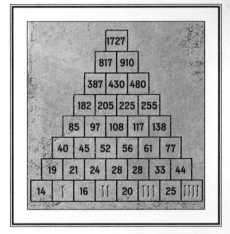

THE FINAL NAME

If you "translate" the bottom row of the pyramid through an alphanumeric code (14, 5, 16, 8, 20, 8, 25, 19), where A = 1, B = 2, etc., you get NEPHTHYS.

VICTORIAN GALLERY
THE YEAR
The four paintings set in London on pages 50 and 51 have numbers in the corners of the paintings. The porcelain plate on page 51 shows features from those paintings. The plate also has four pointing hands indicating the sequence, starting with the image of St Paul's Cathedral at the top (number 1), followed by the numbers 8, 9 and 4 – which gives you the year 1894.

THE STREET
You take the minute hand of each of the clocks on page 48 and translate each number into a letter (where A = 1, B = 2, etc.). You therefore get the numbers 19 – 20 – 20 – 1 – 22 – 15 – 11 – 9 – 3 which translate into letters as S – T – T – A – V – O – K – I – C.

This is an anagram of the London street you are looking for. When you re-sort the letters, it gives you TAVISTOCK Street (Tavistock is also a thriving town in Devon). This can be found in the centre of the map, albeit the name is abridged on the map to Tavistk St. Note that the pink highlighted line is not relevant – it is something of a red herring.

VICTORIAN PUZZLES
VICTORIAN POLICEMAN
From the noticeboard you can deduce that his name must be Johnson.

The clock on page 54 tells you that the time is 10:34 and you know that it is p.m. as it is dark outside. The weekly Monday inspections shows you that the date is between the 18th and the 25th and "This Month's Birthdays" lists Hill and Lowe, whose dates of birth show they were born in June.

There are also apples on the reception desk

which tells you it is a Thursday, so you now know that it is 10:34 p.m. on Thursday 21st June. The final clues are that reception desk staff must be at least pay grade 3, which rules out Bennett, Clark is on holiday this week, Davies is only on call – so would not be manning the desk – and Jackson, who would also normally have been on duty, has been on training that day. This leaves Johnson as the only possible option.

THE SEQUENCE
The sequence of puzzles is: SHADOWS – HEARTBEATS – SLIDING BEDS.

SHADOWS
If you cut out the four "shadows" on the wall and place them above the four "wooden blocks" at the top of pages 64 to 67, they create the following sequences of letters and numbers:
A 1356 B 124 C 2347 D 1247

HEARTBEATS

The sequences found in the Shadows puzzle need to be used to solve the Heartbeats puzzle. There are seven numbered columns in the Heartbeats chart, which indicates you are looking for seven letters, numbers or other characters.

Note which numbers appear after each letter in the Shadows codes. For example, the number 1 appears with the letters A, B and D. Do this for all seven numbers. Next, look at the heartbeats chart. If you combine the bold shapes in column 1 for A (Andrew), B (Brian) and D (Desmond), they form the letter B. The number 2 appears with the letters B, C and D. Using the same method, look in column 2 of the chart and combine the bold shapes for B (Brian), C (Charlie) and D (Desmond). This time you get the letter E. Continue to do this for all seven columns and you get: BEDS − 10.

SLIDING BEDS

The objective here is to move the bed with the star (numbered 11) out of the door, but its path is currently blocked. The beds need to be moved around in order to facilitate that, whilst bearing in mind that they can only be moved lengthways.

Since bed number 15 needs to be moved second, number 24 should be moved first. The full sequence of beds to be moved is: 24 − 15 − 19 − 29 − 29 − 15 − 28 − 19 − 11. Please note that the furthest right of the two numbered 29 will move first.

The solution from the Heartbeats puzzle gave us BEDS − 10, so if you subtract 10 from each of the numbers on the beds, this then gives: 14 − 5 − 9 − 19 − 19 − 5 − 18 − 9 − 1. When converted alphanumerically (A = 1, etc.), this gives the word NEISSERIA. You might recognize that word from the poster on page 69.

GREEK GALLERY
THE YEAR

The key to this puzzle revolves around how ancient Greek letters were used to make up Greek numbers. The sequence of Greek letters around the edge of the plate on page 81 (starting with A at the top and moving clockwise) reflects the sequence of Greek numbers as explained on page 79.

The first nine Greek letters around the plate starting with A represent the first nine numbers (1–9). For example A = 1, B = 2, continuing in a clockwise direction. The next nine letters starting with the letter I represent tens (10–90), so for example I = 10, K = 20 and so on. The final nine letters starting with the letter P represent hundreds (100–900), so for example P = 100, Σ = 200, etc. Finally, if a letter is preceded by a comma, then that represents thousands, so ,A = 1000, ,B = 2000.

In order to find the year, firstly convert the Greek letters on the helmets to Greek numbers. From left to right, the numbers on the helmets are 20, 90, 1000, 4, 300, 5, 700.

The colour of each helmet also appears in the urn design. Replace the asterisk above each helmet with the Greek number related to that colour. By also using the − and = signs you uncover the equation 1395 −724 =. This gives 671, so the year is 671 BCE.

THE LOCATION

On the plate there are ten hands, five of which match a hand in the frieze on page 78, the other five being mirror images of the five hands. The mirror images are red herrings and therefore can be ignored. Only the five matching hands in the correct orientation are the ones to concentrate on. Looking at the frieze, work from left to right and match a hand with the same hand on the plate.

These all point to a Greek letter. The five letters in order are N − A − X − O − Σ, and taking Σ to be the letter Sigma (S), this gives us **NAXOS**, which is where we are told the helmets came from.

GREEK PUZZLES
THE SEQUENCE

In order to find the word required, you need to solve the puzzle by following a sequence of steps as follows: DANCERS − FOOD − MAP − MAZE. This will ultimately lead to a location previously mentioned.

THE DANCERS

The dancers are in five numbered groups and you need to look at each group in turn from 1 to 5. Notice that each set of dancers within those groups are pointing at another set, except for what you must assume to be the final dancers, who are standing with their hands on their hips. This will therefore allow you to work backwards to see where the sequence of pointing starts for each set of dancers.

THE FOOD

The next thing to notice is that the stalls of food are laid out in the same way as the groups of dancers. Looking at the dancers first, in order from 1 to 5, the groups are arranged as follows:
2 : 3 | 3 : 3 | 3 : 2 | 2 : 2 | 2 : 2 : 1

The above arrangements are mirrored in the stalls of food in the following order:
SALT | OLIVES | WINE | MEAT | CHEESE

If you then follow the dancers' directional sequences on each matching food group, you will find a number of place names that form a second sequence. For this, however, you will need to

convert the Greek names to the English alphabet using the plate on page 81. The alphabet is given in the easy hint for this solution.

This gives you the following place names:

SALT: Naxos – Halicarnassus – Pergamum – Lesbos – Ilium

OLIVES: Lemnos – Ilium – Lesbos – Pharsalus – Sparta – Ithome

WINE: Samos – Andros – Athens – Corinth – Pydna

MEAT: Samos – Andros – Athens – Corinth

CHEESE: Lemnos – Andros – Paros – Naxos – Halicarnassus

You know the missing meat is from Athens because of the label you came across on page 82.

THE MAP

The next step in solving this puzzle is to find all of these locations on the map of the Aegean Sea on pages 94 and 95. Following the same order of dancers/food groups, if you list out the directions in which you would need to travel to navigate from and to each of those locations, you find a third sequence as follows:

SALT: Naxos – Halicarnassus – Pergamum – Lesbos – Ilium: **R – U – L – U** (right–up–left–up)

OLIVES: Lemnos – Ilium – Lesbos – Pharsalus – Sparta – Ithome: **R – D – L – D – L**

WINE: Samos – Andros – Athens – Corinth – Pydna: **L – L – L – U**

MEAT: Samos – Andros – Athens – Corinth: **L – L – L**

CHEESE: Lemnos – Andros – Paros – Naxos – Halicarnassus: **D – D – R – R**

THE MAZE

This is the final piece of the puzzle, and you need to use the city maze on page 92 to solve it. Using each of the five directional sequences found in the Map puzzle, start at the point X at the centre of the maze and follow each of those directions. This will lead you to five numbers.

By following each of those sequences, you get the following numbers:

R – U – L – U	**9**
R – D – L – D – L	**12**
L – L – L – U	**9**
L – L – L	**21**
D – D – R – R	**13**

THE FINAL LOCATION

Finally, the numbers found from the maze just need converting using a simple alphanumeric conversion where A = 1, B = 2, etc. That will give you the place name that you need, and one that has already appeared in this section: ILIUM

RESTORATION GALLERY
THE YEAR

The starting point for this puzzle is the cat on page 105. You will notice that there are holes for its eyes and in its ears, as well as four holes on its side that include directional arrows between them. The eyes are clearly looking left and right, and the other two holes are at the top of the ears, which signifies looking up.

The next step is to follow the arrow trail between the holes shown on the side of the cat. The arrows show that the sequence starts in the bottom right-hand corner, then up, then to the left, before finishing in the bottom left-hand corner. Following this sequence on the cat's eyes and ears gives you the following "looking" directions: RIGHT – UP – UP – LEFT.

Next, look at the tapestry, which contains a number of what look like eyes, all looking in various different directions. If you group the eyes by the directions they are looking in, and draw a line joining every eye in each matching group, you can reveal hidden numbers (see image right). For example, if you join all the eyes looking to the right, it gives you a fairly straight line: the number 1. Similarly all the ones looking up, when joined, give the number 6 and the final group, looking left, makes the number 7. You will notice that all the eyes not forming part of a number are looking straight ahead.

You are looking for a year, and if you follow the sequence of RIGHT – UP – UP – LEFT previously found, this will give you the year 1 – 6 – 6 – 7, or 1667.

THE LOCATION

The key to finding the location is to solve the clues given in the three elements on the paper at the bottom of page 109. The note indicates that there are three words that form the location and each of the three elements lead you to one of the words.

The first word can be found by matching the first grid (showing the letters from A to O) with the grid on the side of the chest shown on the right of the painting above. The icons placed on the grid in the chest can also be seen in the main picture,

forming a row that starts on the table. If you "read" them from left to right (gauntlet, helmet, hand, sword, helmet, hand), and then match that order to the icons on the grid on the chest, you can replace them with the respective letters found on the grid in the note to give L – O – N – D – O – N. London.

The second word can be found by looking at the seven images in the second clue and then finding each of those images in the painting on page 107. Next, make a note of the letter shown in the seven boxes of the grid that the images are in and you will get T – H – E – A – T – R – E. Theatre.

For the third word, you will see that the shape of the grid of letters matches the design of the panels on the cabinet on page 106. In order to find this word, look down the side of the cabinet at the five paintings there. Find those five on the front of the cabinet and then match each painting to the letter in the same position on the grid. This gives you R – O – Y – A – L. Royal.

The location is therefore London, Theatre Royal.

RESTORATION PUZZLES
THE SEQUENCE

In order to find the name required, you need to solve the puzzle by following a sequence of steps as follows: BAKERY ITEMS – COST & CHANGE – NUMBER ORDER – WOODEN BEAMS. This will ultimately lead to the name you are looking for.

BAKERY ITEMS

The first step is to notice that in the transcribed script on page 110, certain words have been changed when compared to the script on pages 120–1 that Artur had read to Nell. The four elements that have been changed are: two ginger (line 2); four sugar (line 19); three seed (line 25);

one meat pie (line 27). This makes up a bakery order of ten items as mentioned on page 117 and will need pricing up using the menu on page 116.

COST & CHANGE

The next step is to calculate the cost of the bakery items which are: two ginger-breads (6 farthings); four sugar cakes (8 farthings); three seed cakes (3 farthings); one meat pie (1 penny = 4 farthings). Therefore, the items come to a total of 21 farthings.

You are told on page 117 that Artur always used to buy ten items (see above) and pay with one pound, but would always like his change to be in as few coins as possible. One pound = 4 crowns = 20 shillings/bobs = 60 groats = 240 pennies = 960 farthings. Therefore he would have required the equivalent of 939 farthings in change, and the smallest number of coins that could make up that figure is as follows:

3 crowns (720 farthings)
4 shillings (192)
1 groat (16)
2 pennies (8)
3 farthings (3) (making up a total of 939 farthings)

NUMBER ORDER

The next step is to work out the order of the numbers that you have just found, as you need that to solve the next part of the puzzle. For this, you need to put them in the order as shown at the bottom of page 121 (Farthing, Penny, Groat, Shilling, Crown, Pound). Using the number of coins of each denomination found in the last step, that gives us the following sequence:

Farthing (3), Penny (2), Groat (1), Shilling (4), Crown (3), Pound (0). 3 – 2 – 1 – 4 – 3 – 0.

WOODEN BEAMS

Having found the sequence 321430, you then need to perform some additional calculations using the wooden beams on page 118. These beams, each one representing a coin, are all missing from the grid of the wooden rafters shown on page 111, which also contains some plus and minus numbers. The beams need to be inserted into the correct positions in order to complete the lattice-shaped structure, and each number then added to or subtracted from your original numbers.

The coins match up as follows:

Farthing (+5) – Penny (+13) – Groat (+22) – Shilling (−3) – Crown (+15) – Pound (+4)

Adding or subtracting these numbers from the sequence you already have, you get:

3 + 5 = 8; 2 + 13 = 15; 1 + 22 = 23; 4 − 3 = 1;
3 + 15 = 18; 0 + 4 = 4.

Or 8 – 15 – 23 – 1 – 18 – 4

THE FINAL NAME

The final part of the puzzle is found by a simple alphanumerical conversion, where A = 1, B = 2, etc. Your new numbers of 8 – 15 – 23 – 1 – 18 – 4 convert therefore to H – O – W – A – R – D, so the name you are looking for is Howard.

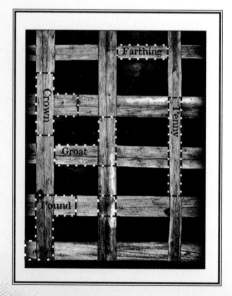

MEXICAN GALLERY
THE DATE

La fecha means 'the date' in Spanish, so the jug is clearly the place to start, and given that two skulls also appear at the base of the jug, you must assume that the skeleton artwork forms a relevant part of the same clue.

The most obvious thing to note about the skeletons is that there are ribs conspicuously missing from several of them. Working from left to right, the numbers of ribs missing from the eight skeletons are: 5 – 4 – 0 – 1 – 3 – 4 – 1 – 9.

The number 72364815 on the jug indicates the order in which those numbers should be placed. Therefore, the seventh number should be followed by the second number and so on. Working through that sequence, you can uncover a new order of 1 – 4 – 0 – 4 – 1 – 9 – 5 – 3, which gives us a date of 14/04/1953, or 14th April 1953.

THE LOCATION

The location can be found by using the jade pendant and the mural, which are both coloured in places with combinations of the same colours: gold, red and black.

There are 26 dangling elements at the base of the pendant. The number 26 is the key here – you can assume that they represent the 26 letters of the alphabet. The mural has ten groups of three arrows running across the top, and each of those colour combinations can be found in the dangling elements of the pendant.

For example, the first group of three arrows are all gold, and the 13th dangling element of the pendant is also all gold, so this first group represents the 13th letter of the alphabet, M. If you repeat that for all ten groups, it gives the following letters: M – E – X – I – C – O – C – I – T – Y.

The location is Mexico City. The plate on page 132 is a red herring, and is not part of any of the puzzles.

MEXICAN PUZZLES
THE SEQUENCE

In order to find the word required, you need to solve the puzzles by following a sequence of steps as follows: MONKEY PUZZLE + WINDOW – WINDOW – TOURIST STAND – FLOWERS. This will ultimately lead to the token you need.

MONKEY PUZZLE + WINDOW

The starting point for this is the Wexell poster on page 143. It lists six Aztec symbols, which are shown in the order – from top to bottom – in which they need to be used in the monkey puzzle tree puzzle on pages 136–7. For example, the bird is the first symbol, which can also be found on the leftmost branch of the tree.

The next thing to notice is that the monkey puzzle tree on page 136 shows a mirror image of the right-hand tree on page 137. However, this tree contains pairs of black-and-white icons in place of each Aztec symbol in the original tree. Thus each Aztec symbol can now be associated with

a pair of black and white icons. In the case of the bird, the icons are a lizard and a fish.

You must then make the connection to the windows on page 140. You can treat the window panes as a grid, with each pairs of icons from the tree on page 136 making up grid references.

For example, the two icons reflecting the bird image previously identified, when used as grid references on the windows, lead us to the yellow skull.

If you do the same with all six pairs of icons in the order shown in the poster, you end up with: yellow skull – yellow guitar – yellow tequila – black sombrero – blue piñata – green plate.

TOURIST STAND

Having found the six images in the monkey puzzle section (yellow skull – yellow guitar – yellow tequila – black sombrero – blue piñata – green plate), you then need to count how many of each item feature in the tourist stand on page 144.

There is one yellow skull, seven yellow guitars, ten yellow tequilas, thirteen black sombreros, zero blue piñatas and fourteen green plates. Therefore, the full sequence of numbers is:
1 – 7 – 10 – 13 – 0 – 14.

However, you believe that the important flower is the one in Frida's hair, so you need to work out what that means before you can complete the number sequence.

FLOWERS

The flower puzzle revolves around the seven flowers in vases seen across the pages 135 to 139. Each one is labelled with a five-digit alphanumeric code, and this code is made up as follows:

1st letter	Colour of the centre	(Red = T; Blue = P; Green = S; Yellow = B)
2nd letter	Petal colour	(Red = L; Blue = R; Green = H; Yellow = O)
3rd letter	Petal shape	(A, E, I, O or U, dependent on petal shape)
4th letter	Stalk shape	(L, N, S or T dependent on stalk shape)
Number at the end	Number of petals	

These petal shapes and stalk shapes can be worked out by logical deduction using the alphanumeric codes on the flower vases.

You need to find the key piece of information, which you believe relates to the flower in Frida's hair. This is worked out by using the same key as above. Looking at each element of the flower in turn, you end up with P – L – U – S – 5. PLUS 5.

This tells you that you need to add 5 to each of the numbers that you worked out in the previous part of the puzzle. Therefore 1 – 7 – 10 – 13 – 0 – 14 becomes: 6 – 12 – 15 – 18 – 5 – 19.

The final step is to convert that using an alphanumeric code, where A = 1, B = 2, etc. This gives you: F – L – O – R – E – S.

FLORES is the Spanish word for flowers, which is your token to get home.

WHITEBOARD
The key to this puzzle is to insert all of the assumed names of the mysterious traveller into the grid, the first one, Saren, having already been inserted.

The names to insert, reading downwards, are: Saren – Aiden – Orfio – Artur – Vittu. The letters in the bold boxes across the diagonal are the important ones, which are: S – I – F – U – U.

The final important thing to spot is the –1 in the bottom right-hand corner. If the diagonal letters in the grid shift one place back in the alphabet, you get the name we are looking for: R – H – E – T – T, or Rhett.

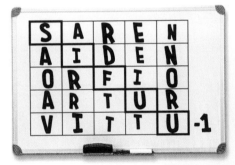

THE FUTURE GALLERY
THE DATE

The key to finding this four-digit number, representing a year in the future, is to spot the connections between the *Newtopia* painting on page 157, the fabric patterned with lines on page 160 and the four scrawled images under the Newtopia name on page 158.

If you cut out the lined fabric as indicated, you will notice that the top and bottom lines match up with the top and bottom of the *Newtopia* painting. The numbered lines in between line up with the tops of various buildings in the painting and the order required is shown by the four scrawled outlines on page 158 which correspond with the top sections of certain buildings.

The first 'etching' has the same outline as the top of the second building from the right, and when that is lined up with the numbered lines from page 160, this building aligns with the number 2, so that is the first of our four numbers.

Following the same process with the other three etchings, the second etching matches the tallest building, second from the left, which lines up with the number 4. The third etching is the smallest building on the extreme right, which is the number 1, and the final etching represents the fourth building from the right, which lines up with the number 0.

Therefore the year in the future we are looking for is the year 2410.

THE LOCATION

The important things to note here are that there are three wheels which can all be cut out, and also that each of these wheels can fit inside each other to form 'a wheel within a wheel within a wheel'.

The outer wheel is the large cogwheel on page 163 which contains the letters A to X. Within that should be placed the wheel from page 156 which contains six futuristic symbols. The final inner wheel is the dimmer switch numbered 1 to 6 from page 162.

There are six clues to solve which are shown in the six sections on the orbs on pages 155 and 157. These show you how to line up the three wheels and each of those clues in turn will reveal six letters of the alphabet, leading to a six-letter word which will give us the location we are looking for.

The first clue tells us to line up the number 2 with the symbol which looks like 'two marshmallows on a skewer' and then to line up the letter G in the outer wheel with the symbol showing 'two circles inside a box'. Once all three wheels are in place, if you follow the number 1 (this being the first clue), it points to the letter W, so that is our first letter. Similarly, the last clue asks us to align the number 5 with the same 'marshmallow' symbol but this time to align the 'alienesque symbol with two eyes sticking up' with the letter T (as shown below). This being the sixth clue, we follow the number 6 this time and that points to the letter L. If you do this for all six clues, we end up with the letters W – E – X – E – L – L.

Therefore our location is Wexell.

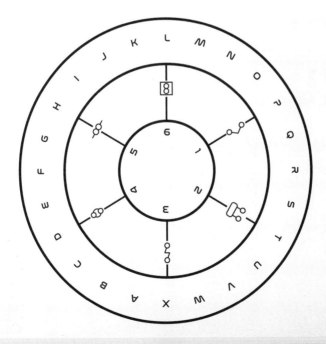

THE FUTURE PUZZLES
THE SEQUENCE

In order to find the word required, you need to solve the puzzle by following a sequence of steps as follows: SPACESHIP – BOOKS – SPEAKING ICON. This will ultimately lead to a name previously mentioned.

SPACESHIP

The starting point with this part of the puzzle is the map of the spaceship and the route that needs to be taken in order to get from the H-Lab to the Medical Bay. However, the maintenance log on page 171 tells you that certain rooms and corridors are closed for various reasons and so there is only one path that can be taken.

The route is as follows: H-Lab – Crew's Quarters – Observation Deck – Oxy-Gen – Airlock – Cryo Storage – Bridge – Medical Bay. Each of these rooms is colour-coded and that then gives the following sequence of colours: brown – red – blue – black – yellow – purple – white – green.

BOOKS

Having found a sequence of eight different colours in the first part of the puzzle (brown – red – blue – black – yellow – purple – white – green), that same sequence of colours needs to be used with the books on the shelf.

The dates of publication are written vertically on all the books, although the dates are not in alignment with each other. There is an additional clue though on the wall behind the books where an arrow indicates that there is a line running through all the dates which is important to us. Reading across that line from left to right gives us the following numbers: 0 – 8 – 0 – 1 – 2 – 8 – 2 – 5.

However, the sequence of colours previously found needs to be utilised here in order to rearrange all the books in the same order of colours. Having done that, the sequence of the numbers changes to 1 – 8 – 8 – 5 – 2 – 0 – 2 – 0. So the final number we require is 18852020.

SPEAKING ICON

The speaking icon gives us our next clue, with the eight lines below the icon representing how the number found previously should be broken down.

The eight lines are broken down as | _ _ | _ | _ | _ _ | _ _ | and each line represents one of the numbers in our previous number of 18852020. Taking into account the new split, this gives us a new sequence of numbers being 18 – 8 – 5 – 20 – 20. Using alphanumeric conversion where A = 1, B = 2, etc., we get the letters R – H – E – T – T, so our name is RHETT.

CAVE

The key to this part of the puzzle is via the Martagon Turksap DNA strand, and the solution is in essence in three parts.

The first thing to note are the four letters (T, C, A and G) pointing to different bars on the main DNA strand, and to note that each of those

letters points to a different colour of bar (G = yellow, C = pink, A = green and T = blue).

The second part is to look at the five unknown strands of DNA shown vertically, and the key here is to look at the position of the five slightly glowing bars. Looking at the colours of those bars, they are in turn blue – yellow – blue – blue – blue. Matching those colours to the letters in the first part, we get T – G – T – T – T.

The final element to this puzzle requires information from the five vines hanging down, namely how many flowers appear on each successive vine. The numbers in turn are 2 – 2 – 0 – 0 – 1, and if you add these numbers to the five letters already found (i.e. adding 1 will mean moving to the next letter of the alphabet), the final letters become V – I – T – T – U, so the name we are looking for is VITTU.

THE BATTERY PUZZLE

Charge the earpiece with one of the orbs on the spaceship.

THE FINAL NAME

VITTU is an anagram of IVTUT, which was the name of the mummy in Chapter 1 set in ancient Egypt.

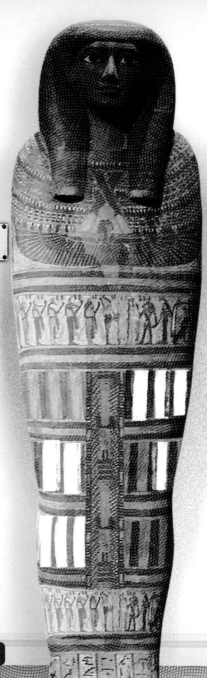

VITTU

PICTURE CREDITS

The publishers would like to thank the following sources for their kind permission to reproduce the pictures in this book:

Alamy
Art Institute of Chicago
Shutterstock
Cleveland Art Museum
The Metropolitan Museum of Art
Rijksmuseum Amsterdam